NICOTEXT

TRUTH
OR
BULL

BY
MORGAN LARSSON OCH
HELA CHRISTERREDAKTIONEN.

Text: Morgan Larsson, Christer Lundberg, Emma Olsson-Feuk,
Ylva Lindvall och Rickard Nerbe

Edited by: Jaclyn Bond

Copyright © NICOTEXT 2009 All rights reserved.
NICOTEXT part of Cladd media ltd.
www.nicotext.com
info@nicotext.com

Printed in Poland
ISBN: 978-91-85869-47-3

Greetings dear reader,

This book contains more than 450 questions that prove that reality isn't always what you thought it to be. The most unbelievable can be the absolute truth, while as your view on what's true can be pure bullshit. But not always. Sometimes what seems true actually is, and what smells like bullshit is exactly that. This doesn't make it easier, but it does make it more fun! Your job is to keep a straight line in this jungle of questions, so don't lose yourself among false facts and seductive lies.

The rules are as simple as the competition is difficult; just answer truth or bullshit to the question asked. One big benefit with this instructive game is that the questions are equally cunning for everyone. It doesn't matter if you're 5 or 95 years old, if you're a member of Mensa or if you were always in the bottom of your class. Since it may just be as big of a mistake thinking too much as thinking too little – everyone has the same chance of winning!

To separate Truth from Bullshit takes more than just intelligence.
The Truth or Bullshit book is a treasure if you want to spice life up a little. The drama, the cunningness, the thirst for winning and entertainment will all add to your quality of life at the same time as your general know-how storage suddenly grows in the most unexpected places.

Rules

The rules are as simple as the competition is difficult. Your job is to answer each statement with a Truth or Bull. Play on your own or with others and mark your answers in the boxes to the right. You will find the correct answer on the following page.

Here are some options:

1. The truth master (one on one)

If you're having a party for example, or a get together with some friends or some other event, you can ask the contestants to line up next to each other. Then the game leader asks a Truth or Bullshit question to each one. If you answer correctly, you're still in the competition and in line, but if you get it wrong you have to leave the line. Then you keep this up until there's only one person left - the Truth master.

2. The lie detectors (teams)

If you want the event to heat up a little, and the contestants to start socializing, dividing people into teams is a great idea. You let the teams sit in their own corners where they have ten or so Truth or Bullshit questions written down for the team to ponder on. Each team gets the same questions and a certain amount of time to think them over. When the time is up, each team gives their answers out loud with a short motivation and after that, the correct answer is revealed. When all questions are done, you tally the result and crown the winning team.

3. First to five

In this version, it's about reaching a certain amount of correct answers to win. This is not the best suited version for the large gathering of friends, eight people at the most. The contestants gets a Truth or Bullshit question one by one, and the ones who gets it right gets a point while the person who gets it wrong obviously doesn't get anything. Each person gets a new question each round until someone has gotten five answers right.

4. Three in a row

Another occasion when Truth or Bullshit is ideal is during your travels. In the car, on the train, at the airport or wherever you are whilst you're moving. This is an excellent opportunity to play Three in a row. As soon as someone gets a question wrong, the quizzing continues onto the next person who's going to try to get three in a row. If that person fails, you move onto the next one, and so forth, until someone gets three correct answers in a row and wins the whole thing.

GAME ON!

TRUTH OR BULL

QUESTION

1. The symptom for the disease Oculus Nasumae is a thin green layer covering the eye. Oculus Nasumae is also known as Snoteye because when the patient cries, their tears resemble snot.

Truth / Bull
☐ ☐
☐ ☐
☐ ☐
☐ ☐

2. The expression "mad as a hatter" is quite common in England. It originates from hat makers who would often become mentally affected by the mercury used in the hat making process.

Truth / Bull
☐ ☐
☐ ☐
☐ ☐
☐ ☐

3. Actor George Clooney began his TV career when he was 5 years old.

Truth / Bull
☐ ☐
☐ ☐
☐ ☐
☐ ☐

4. In the enclosed city of Ahmedon in western India, leopards and humans live side by side. It is not unusual for leopards (along with goats) to provide people with milk.

Truth / Bull
☐ ☐
☐ ☐
☐ ☐
☐ ☐

5. Bruce Willis does the voice of the baby in the 1989 movie Look Who's Talking.

Truth / Bull
☐ ☐
☐ ☐
☐ ☐
☐ ☐

ANSWER

1 BULL

2 TRUTH
Prolonged exposure to mercury during the fur preparation state took its toll on hatters of old, eventually causing their legendary madness.

3 TRUTH
George made his debut on his father's talk show,
The Nick Clooney Show.

4 BULL

5 TRUTH

QUESTION

1 The traditional Turkish red hat known as a Fez is named after the Turkish word for pot or bowl.

Truth / Bull
☐ ☐
☐ ☐
☐ ☐
☐ ☐

2 Workers in South Africa's public sector went on strike due to low wages and lack of benefits. Workers also complained that their jobs were so intense, they were unable to perform sexually, thus reducing the possibility of having large families.

Truth / Bull
☐ ☐
☐ ☐
☐ ☐
☐ ☐

3 One megabyte is equal to 1024 kilobytes.

Truth / Bull
☐ ☐
☐ ☐
☐ ☐
☐ ☐

4 A mosquito has 47 teeth.

Truth / Bull
☐ ☐
☐ ☐
☐ ☐
☐ ☐

5 Moonwalker Neil Armstrong once said: "I believe that every person has a limited number of heartbeats and I am not wasting mine running around and exercising".

Truth / Bull
☐ ☐
☐ ☐
☐ ☐
☐ ☐

ANSWER

1 BULL
The hat is named after the Moroccan city of Fez where the berries used to colour the hats are grown.

2 TRUTH

3 TRUTH

4 TRUTH

5 TRUTH

QUESTION

Cuban singer Gloria Estefan has six fingers on her left hand.

Truth / Bull
☐ ☐
☐ ☐
☐ ☐
☐ ☐

The game Corona was invented in 1953 by the Crown brothers from Wisconsin, USA. To amuse themselves during a bout of chickenpox, brothers Rohan and Russ used pencils to knock Cheese Doodles down from their nightstand into a mug.

Truth / Bull
☐ ☐
☐ ☐
☐ ☐
☐ ☐

There is a disease called Tentanus.

Truth / Bull
☐ ☐
☐ ☐
☐ ☐
☐ ☐

There is a type of leech that has 32 brains.

Truth / Bull
☐ ☐
☐ ☐
☐ ☐
☐ ☐

A study done by the German newspaper Die Welt showed that one in nine unmarried German men are virgins.

Truth / Bull
☐ ☐
☐ ☐
☐ ☐
☐ ☐

ANSWER

1 BULL

2 BULL

3 BULL

4 TRUTH
It is called the European medicine leech and it can suck in up to ten times its own weight in blood.

5 BULL

QUESTION

Truth / Bull

1. An anaconda gives birth to live babies.
☐ ☐
☐ ☐
☐ ☐
☐ ☐

Truth / Bull

2. The hard rock band AC/DC took its name from the sign on an electric chair used for executions.
☐ ☐
☐ ☐
☐ ☐
☐ ☐

Truth / Bull

3. In the city of Pampanga in the Philippines, locals celebrate Good Friday by binding and whipping male volunteers.
☐ ☐
☐ ☐
☐ ☐
☐ ☐

Truth / Bull

4. According to an old Icelandic folktale, human ears are actually the beginnings of wings. Over time, with the aid of evolution, growth of our wings became stunted and eventually refined to the shape they are today.
☐ ☐
☐ ☐
☐ ☐
☐ ☐

Truth / Bull

5. In the city of Gloucestershire in England a yearly competition is held in which people chase a rolling cheese down a big hill. The cheese gets a brief head start before competitors scramble down the hill after it. Broken bones and injuries are common in this competition.
☐ ☐
☐ ☐
☐ ☐
☐ ☐

ANSWER

1 TRUTH

2 BULL
The name comes from an abbreviation for alternating current/direct current that brothers Malcolm and Angus Young saw on their younger sister's sewing machine.

3 TRUTH
This tradition started 1962 and has grown increasingly popular with the aid of media and tourism.

4 BULL

5 TRUTH
Ambulances join the many thousands of spectators waiting at the bottom of the hill. One year a spectator was badly injured when a cheese hit him in the head.

QUESTION

Truth / Bull

1 The biblical character Job had three daughters named Jemina, Kesia and Keren-Happuk. In the Swedish version of the Bible, the girls are named Lil'pigeon, Cinnamonflower and Powder.

☐ ☐
☐ ☐
☐ ☐
☐ ☐

Truth / Bull

2 In the movie Die Hard, Bruce Willis' character John McCane fights German terrorists. In the German-dubbed version of the film, the terrorists are from an anonymous European country.

☐ ☐
☐ ☐
☐ ☐
☐ ☐

Truth / Bull

3 A fifty-two-year-old Greek woman gave birth to her own grandchildren. The woman was a surrogate mother to her own daughter and gave birth to twin boys – her own grandchildren.

☐ ☐
☐ ☐
☐ ☐
☐ ☐

Truth / Bull

4 The record for the most people dressed as Robin Hood in one location was recently broken near Nottingham Castle in England. No less than 165 persons dressed as Robin Hood showed up.

☐ ☐
☐ ☐
☐ ☐
☐ ☐

Truth / Bull

5 Spinach was once used as a bandage. In days gone by, spinach leaves were laid over wounds for a cooling effect

☐ ☐
☐ ☐
☐ ☐
☐ ☐

ANSWER

1 TRUTH

2 TRUTH

3 TRUTH
A Greek court granted the woman permission to be a surrogate mother for her own daughter, despite laws which require surrogate mothers to be under fifty years of age.

4 TRUTH
The Robin Hoods were aged between fifteen months and sixty years old.

5 BULL

QUESTION

1 Scientist Albert Einstein had a theory that if all the bees in the world were to die, the human race would die out within four years.

Truth / Bull
☐ ☐
☐ ☐
☐ ☐
☐

2 According to the Bible, Adam reached 2563 years of age.

Truth / Bull
☐ ☐
☐ ☐
☐ ☐
☐ ☐

3 A British man named David Brown woke one morning after having dreamt about a certain cell phone number. Curious, Mr. Brown sent a text to the number and a surprised woman replied. The pair continued texting, formed a relationship and have since married.

Truth / Bull
☐ ☐
☐ ☐
☐ ☐
☐ ☐

4 Napoleon offered a prize for whoever could invent a way of conserving food so that his troops might eat better when at war. The prize, 12 000 francs, was won by inventor Nicholas Appert who came up with the idea for canned food.

Truth / Bull
☐ ☐
☐ ☐
☐ ☐
☐ ☐

5 Actress Marilyn Monroe used to have one shoe heel made shorter so that when she walked her body would tilt back and forth and appear sexier.

Truth / Bull
☐ ☐
☐ ☐
☐ ☐
☐ ☐

ANSWER

1 TRUTH

2 BULL
Adam died at the ripe old age of 930.

3 TRUTH

4 TRUTH
The year was 1804 and Appert's revolutionary
invention then spread around the world.

5 TRUTH

QUESTION

1 Domestic guru Martha Stewart once dated actor Anthony Hopkins. After seeing Anthony in the role of Hannibal Lector in Silence of the Lambs, Martha had second thoughts and broke up with him.

Truth / Bull
☐ ☐
☐ ☐
☐ ☐
☐ ☐

2 Lady Diana was so afraid of losing her hair that she slept with a specially constructed hair net to reduce the quantity of hair that fell out.

Truth / Bull
☐ ☐
☐ ☐
☐ ☐
☐ ☐

3 Actress Penelope Cruz took the name Cruz to honour her Catholic faith. Her real name is actually Sophia Penelope Serrano. In the movie Vanilla Sky, her character has her birth name Sophia Serrano.

Truth / Bull
☐ ☐
☐ ☐
☐ ☐
☐ ☐

4 The disease priapism involves prolonged and often painful erection of the penis.

Truth / Bull
☐ ☐
☐ ☐
☐ ☐
☐ ☐

5 President John F Kennedy suffered from Addison's disease, which was relieved when he sat in a rocking chair. Thus, the rocking chair became a symbol for JFK.

Truth / Bull
☐ ☐
☐ ☐
☐ ☐
☐ ☐

ANSWER

1 TRUTH

2 BULL

3 BULL
Penelope has always had the name Penelope
Cruz Sanchez.

4 TRUTH
Priapism is a blood related condition, unrelated to
sexual activity. The condition can become serious
enough to require surgery.

5 TRUTH
Addison's disease attacks the adrenal glands.

QUESTION

1. Canadian pop star Avril Lavigne has recorded the chorus for her song Girlfriend in seven different languages including Japanese and Mandarin.

Truth / Bull
☐ ☐
☐ ☐
☐ ☐
☐ ☐

2. The OK sign (made by holding the thumb and index finger in a ring shape and sprawling the remaining fingers) is not so harmless in other countries. In Brazil and Germany the gesture is vulgar and obscene, while in Japan it means money.

Truth / Bull
☐ ☐
☐ ☐
☐ ☐
☐ ☐

3. 18th Century Prussian Queen Lovisa Ulrika was known as a real slave driver. She kept her "dressers" in cages for fear of them gossiping about her naked body.

Truth / Bull
☐ ☐
☐ ☐
☐ ☐
☐ ☐

4. Famous composer Amadeus Mozart is behind the composition Leck mich im Arsch, or Lick my Arse in English.

Truth / Bull
☐ ☐
☐ ☐
☐ ☐
☐ ☐

5. San Francisco was called Yorba Buena up until 1847.

Truth / Bull
☐ ☐
☐ ☐
☐ ☐
☐ ☐

ANSWER

1 TRUTH

2 TRUTH

3 BULL

4 TRUTH

5 TRUTH
The name San Francisco was taken after the city's protective saint: St Francis of Assisi.

QUESTION

The common carp is the only living fish that has both gills and fully developed lungs.

Truth / Bull

Mike Yurosek is a Californian farmer and also the man behind the mini carrot. Mike created the method to make regular carrots smaller during the early 1980s.

Truth / Bull

Leonardo da Vinci's portrait "Mona Lisa" was first called "Marie Charlotte" after the mayor of Paris' wife. The mayor became so jealous after seeing the artist's soulful depiction of his wife that he forbade Leonardo to name his painting "Marie Charlotte".

Truth / Bull

Actor Andy Garcia was born as a Siamese twin.

Truth / Bull

Asperman-Scott's syndrome is a liver disease that only affects homosexual men. The discovery of the disease has renewed the idea that homosexuality is genetic.

Truth / Bull

ANSWER

1 BULL

2 TRUTH

3 BULL
Leonardo never gave his painting a title. The name "Mona Lisa" was given to the painting after the model Lisa. Mona is a common diminutive of Madonna, and thus the painting is called "Her Honour Lisa".

4 TRUTH
A twin the size of a tennis ball was attached to Andy Garcia's shoulder, but was surgically removed.

5 BULL

QUESTION

1 Christian Dior, Dolly Parton and Liv Tyler all have a rose named after them.

Truth / Bull
- []
- []
- []
- []

2 Oasis' Noel Gallagher named his cats after his favourite brand of cigarettes.

Truth / Bull
- []
- []
- []
- []

3 Joan of Arc was only nineteen years old when she was burned at the stake.

Truth / Bull
- []
- []
- []
- []

4 Kiwi fruit were originally called Mongolian Apples.

Truth / Bull
- []
- []
- []
- []

5 Princess Diana, Bob Marley and Marilyn Monroe all died at the age of thirty-six.

Truth / Bull
- []
- []
- []
- []

ANSWER

1 TRUTH

2 TRUTH
The cats are named Benson and Hedges.

3 TRUTH

4 BULL
Kiwis were originally called Chinese Gooseberries.

5 TRUTH

QUESTION

Truth / Bull

Up until 1937, it was illegal to wear women's clothing in public in France if you were a man. The only way to bypass this law was to attach a piece of paper with the words "I am a man" (je suis un homme) to your clothing. According to the court, this prevented anyone from being tricked into believe a man was a woman.

Truth / Bull

During the middle ages in Japan, only the internal organs of hunted animals were eaten. The rest was left for other predators. It was only when Japan came in contact with Western civilisation that they started eating the meat of animals.

Truth / Bull

In Syria it's not Santa who brings gifts to children at Christmas but rather one of the three wise men's camels.

Truth / Bull

Morrissey, Paul McCartney and 50 Cent have more in common than just music. All three artists are also left-handed.

Truth / Bull

In 1888, the Pope ordered the kidnapping of six-year-old Edgardo Mortara from his family home. Mortara, whose parents were Jewish, had been given a Catholic baptism by the family maid. The law at the time stated that Jews weren't allowed to raise a Christian child, even if it was their own.

ANSWER

1 BULL

2 BULL

3 TRUTH

4 TRUTH

5 TRUTH
The boy was kidnapped on June 23 1858 and the event created worldwide controversy.

QUESTION

Jennifer Wilbanks is known as "The Runaway Bride" after she faked a kidnapping to escape her own wedding. Four days before the marriage, Jennifer disappeared before calling her fiancé to tell him she had been kidnapped. A nationwide search took place before it was discovered that Jennifer had faked the whole thing.

Truth / Bull
☐ ☐
☐ ☐
☐ ☐
☐ ☐

The word "koala" comes from the Aboriginal word for "no drink". Koalas rarely drink as the leaves they eat contain enough fluid to sustain them.

Truth / Bull
☐ ☐
☐ ☐
☐ ☐
☐ ☐

Jodie Foster recorded a number of songs in French during the 70's including the disco-track La Vie C'est Chouette.

Truth / Bull
☐ ☐
☐ ☐
☐ ☐
☐ ☐

Hungarian twins Ferenc and Franz lived together in the little village of JszberÈny. When they were 69 years old, they were run over and killed in two separate car accidents within three minutes of each other.

Truth / Bull
☐ ☐
☐ ☐
☐ ☐
☐ ☐

During the early 20th century, there was an actor named Harrison Ford, but unlike the present Ford, this one was a star in silent films.

Truth / Bull
☐ ☐
☐ ☐
☐ ☐
☐ ☐

ANSWER

1 TRUTH
Jennifer Wilbanks was sentenced to two years probation and community service for giving false information to the police.

2 TRUTH

3 TRUTH
Jodie Foster is fluent in French.

4 BULL

5 TRUTH
Harrison Ford died in 1957 when the present day Harrison Ford was 15 years old. Both men have a star each on the Hollywood Walk of Fame.

QUESTION

Ferdinand Porsche, the man behind the car of the same name, is also behind the world's most produced car: the Beetle.

Truth / Bull

☐ ☐
☐ ☐
☐ ☐
☐ ☐

Young design student Carolyn Davidson created Nike's iconic logo called the "swoosh" in 1971. Davidson was paid $35 for her work.

Truth / Bull

☐ ☐
☐ ☐
☐ ☐
☐ ☐

While the Lamborghini brand is known today for producing high-powered sports cars, the company originally produced tractors.

Truth / Bull

☐ ☐
☐ ☐
☐ ☐
☐ ☐

The Ishihara-test was used during the 1960's to discover deviant sexual intentions and suicidal thoughts.

Truth / Bull

☐ ☐
☐ ☐
☐ ☐
☐ ☐

Great Britain has the most surveillance cameras in the world, many of which can talk.

Truth / Bull

☐ ☐
☐ ☐
☐ ☐
☐ ☐

ANSWER

1 TRUTH
Ferdinand Porsche originally worked for Volkswagen.

2 TRUTH
The company was called Blue Ribbon Sports, but soon became Nike. In 1983, Nike showed it's appreciation by presenting Ms Davidson with a diamond "swoosh" ring and a large envelope filled with valuable Nike stock.

3 TRUTH
Lamborghini tractors are still produced today.

4 BULL
An Ishihara-test is used to determine colour blindness.

5 TRUTH
The talking cameras are connected to a central surveillance central where the staff can talk through speakers attached to the cameras when they see someone being a nuisance.

QUESTION

Truth / Bull

1. Artist Vincent van Gogh presented his cut-off ear to his brother Theo with the words: "Give this to my unborn son and tell him that this is my last creation".

☐ ☐
☐ ☐
☐ ☐
☐ ☐

Truth / Bull

2. The hooded seal makes its nose swell like a balloon to attract females.

☐ ☐
☐ ☐
☐ ☐
☐ ☐

Truth / Bull

3. Elvis Presley had sandy blonde hair.

☐ ☐
☐ ☐
☐ ☐
☐ ☐

Truth / Bull

4. Adolf Hitler had brown eyes.

☐ ☐
☐ ☐
☐ ☐
☐ ☐

Truth / Bull

5. In the movie Titanic, Leonardo DiCaprio's character Jack Dawson draws a naked portrait of Kate Winslet's character, Rose DeWitt Bukater. The sketches used in the film are drawn by Leonardo DiCaprio himself.

☐ ☐
☐ ☐
☐ ☐
☐ ☐

ANSWER

1
BULL

2
TRUTH
The hooded seal's nose is composed of leathery skin that becomes large and red when expanded, which is used to impress females.

3
TRUTH
Elvis dyed his hair black and is said to have gone completely grey by the age of 35.

4
BULL
Hitler had light-blue eyes.

5
BULL
Director James Cameron claims to have drawn the sketches.

QUESTION

In 1906 production of the first model T-Fords began. They were only ever painted red as it was considered that such a fast vehicle had to be painted in a colour warning of danger.

Truth / Bull

□ □
□ □
□ □
□ □

Brazilian footballer Manuel "Garrincha" dos Santos had very unusual legs. His right leg turned inward and his left bowed outward causing the appearance of two left legs.

Truth / Bull

□ □
□ □
□ □
□ □

In Wellington, New Zealand there is a bank in which you can deposit more than just money, you can deposit your children and your tired body too as the bank is combined with a day-care centre and spa resort.

Truth / Bull

□ □
□ □
□ □
□ □

Many seamen believe in the superstition that if an albatross is killed by a crew member, an accident will befall the ship.

Truth / Bull

□ □
□ □
□ □
□ □

The Dani people of New Guinea celebrate a girl's first menstrual period with dancing and mud wrestling. A large fire is also lit, and the direction in which the smoke blows is where the girl will find her future husband.

Truth / Bull

□ □
□ □
□ □
□ □

ANSWER

1 BULL
The first cars were black.

2 TRUTH
Garrincha's left leg was also six
centimetres shorter than his right.

3 BULL

4 TRUTH

5 TRUTH

QUESTION

In the small village of Taize in southern France as many as twenty of the 200 inhabitants have the very rare genetic deviation albinism which causes a shortage or total loss of melanin pigment.

Truth / Bull

The song Macarena by the group Los del Rio was originally titled "Madonna" but a name change was inevitable after a fight with the famous artist.

Truth / Bull

The view of Martin Luther as a puritan ascetic is not accurate. Actually, Luther enjoyed taking a drink or two and recommended repressed men to dream about women.

Truth / Bull

Leprosy is a very contagious disease and can be transferred by light touch.

Truth / Bull

Adolf Hitler was a vegetarian.

Truth / Bull

ANSWER

1 BULL

2 BULL

3 TRUTH

4 BULL
Leprosy is one of the least contagious of all contagious diseases.

5 BULL
Hitler was advised by his doctor to follow a vegetarian diet (which he did to a large extent) but could never break his carnivorous habits completely.

QUESTION

Truth / Bull
☐ ☐
☐ ☐
☐ ☐
☐ ☐

1 According to the Bible, humanity's first killing was when Cain killed his brother Abel.

Truth / Bull
☐ ☐
☐ ☐
☐ ☐
☐ ☐

2 French was the official language in England for 300 years.

Truth / Bull
☐ ☐
☐ ☐
☐ ☐
☐ ☐

3 Shark is the only animals known to be immune to cancer.

Truth / Bull
☐ ☐
☐ ☐
☐ ☐
☐ ☐

4 The Ukrainian national anthem Sjtje ne vmerla Ukraina has no less than 113 verses.

Truth / Bull
☐ ☐
☐ ☐
☐ ☐
☐ ☐

5 A small ethnic group in Tahiti, does not tolerate any mistreatment of animals. Harming an animal is punished with instant exclusion from the group. The offending member is forced to live in isolation, be it man, woman or child.

ANSWER

1 TRUTH
Adam and Eve's eldest son Cain was later banished by God to the country of Nod.

2 TRUTH
After the Norman invasion of 1066, French became the official language of England, spoken by the upper social classes. English was used only by the working class and was greatly influenced by French.

3 TRUTH
This makes the shark a very interesting object of study for cancer researchers.

4 BULL
It just has one verse.

5 BULL

QUESTION

Among the Newa people it is common for girls to marry three times.

Truth / Bull

☐ ☐
☐ ☐
☐ ☐
☐ ☐

Hollywood was named through a competition organised by a production company in California. The proposal "Hollywood" came from a fan of the movie Breakfast at Tiffany's and is a reference to the main character Holly Golightly.

Truth / Bull

☐ ☐
☐ ☐
☐ ☐
☐ ☐

The time period referred to as the Classical era took place between 800 B.C. and 500 A.D.

Truth / Bull

☐ ☐
☐ ☐
☐ ☐
☐ ☐

Ötzi the iceman, who was found in the snow in the Alps in 1992 is thought to have lived in around 3300 B.C. Ötzi's body was covered in no less than 58 tattoos.

Truth / Bull

☐ ☐
☐ ☐
☐ ☐
☐ ☐

Kinder Surprise founder Thomas Schultz died last year. When he was buried the casket was made entirely out of chocolate and shaped like a giant Kinder Surprise in accordance with Thomas Schultz's wishes.

Truth / Bull

☐ ☐
☐ ☐
☐ ☐
☐ ☐

ANSWER

1

TRUTH
She marries once to the god Vishnu, once to the god of sun Surya, and once to a man.

2

BULL

3

TRUTH

4

TRUTH
The tattoos were mostly lines and circles.

5

BULL

QUESTION

People walking with a forward slant may have worse posture than others, but they do walk faster. A Canadian report from Ryersons University in Toronto shows that people walking with a slight forward slant are over ten percent faster than those with straight posture.

Truth / Bull
☐ ☐
☐ ☐
☐ ☐
☐ ☐

The Scott William Kidd was a ship owner who received a mission from the English government to catch pirates. A couple of years far into the mission, William himself became the pirate known as Captain Kidd.

Truth / Bull
☐ ☐
☐ ☐
☐ ☐
☐ ☐

The first woman to win Wimbledon was named Maud.

Truth / Bull
☐ ☐
☐ ☐
☐ ☐
☐ ☐

Recently discovered documents in Switzerland suggest that Willhelm Tell (William Tell), who was long thought to be only a legend, really existed.

Truth / Bull
☐ ☐
☐ ☐
☐ ☐
☐ ☐

The name of the festival Mardi Gras, which is celebrated in New Orleans among other places, means Fat Tuesday.

Truth / Bull
☐ ☐
☐ ☐
☐ ☐
☐ ☐

ANSWER

1 BULL

2 TRUTH
Captain Kidd was hanged in 1701.

3 TRUTH
Maud Watson defeated her sister Lillian in the finals.

4 BULL
Wilhelm Tell is a fictional Swiss national hero, known for his skills with a crossbow.

5 TRUTH
This year Mardi Gras was celebrated the 20th of February.

QUESTION

Truth / Bull

1. The capital of Burma, or Myanmar as it is officially called, is Naypyiodaw.

☐ ☐
☐ ☐
☐ ☐
☐ ☐

2. The first real crossword was published in the Danish magazine Danske Hjemjournal in 1934.

☐ ☐
☐ ☐
☐ ☐
☐ ☐

3. The largest fruit fly ever found was as big as a child's fist and was found in a kitchen in Santiago, Chile in 1966.

☐ ☐
☐ ☐
☐ ☐
☐ ☐

4. With the help of radiocarbon dating, it is possible to date plant or animal remains up 50,000 years back in time.

☐ ☐
☐ ☐
☐ ☐
☐ ☐

5. Princess Paloma of Catalonia experienced a dreadful wedding day 1977. Shortly after the ceremony her father, the king, was captured and forced to abdicate. After this the entire royal family was arrested and Paloma's new husband was beheaded. Paloma was then forced to marry the new king, who had overthrown her own father.

☐ ☐
☐ ☐
☐ ☐
☐ ☐

ANSWER

1 TRUTH
Rangoon, the country's largest city, was the capital up until November 2005 when the decision was made to move it to Naypyiodaw by the county's "leaders".

2 BULL
It was published in the magazine New York World in 1913.

3 BULL

4 TRUTH
Radiocarbon dating measures the degree of radioactivity.

5 BULL

QUESTION

1 The first bomb dropped by the allies over Berlin during World War II hit the Berlin Zoo, killing the park's only elephant.

Truth / Bull
☐ ☐
☐ ☐
☐ ☐
☐ ☐

2 Since 2001, China's "Love Your Feet" day has been celebrated on November 4th. The day was founded by the Chinese department of health.

Truth / Bull
☐ ☐
☐ ☐
☐ ☐
☐ ☐

3 The tradition of tying empty cans to a newly-wed couple's car has its origins in the USA during the 1920s. Prior to the depression it was customary to honour the couple with a large orchestra, but when the economy fell apart, cans were tied to the car as a noisy, less melodic alternative.

Truth / Bull
☐ ☐
☐ ☐
☐ ☐
☐ ☐

4 When Stalin was in power, he sometimes liked to subject his closest men to practical jokes even though it was strictly forbidden for them to retaliate. He once exchanged general Vorusilov's daily meal of sour milk to a bowl of bird droppings.

Truth / Bull
☐ ☐
☐ ☐
☐ ☐
☐ ☐

5 If you want to court an Estonian, refrain from giving away red roses. In Estonia, red roses are associated with funerals.

Truth / Bull
☐ ☐
☐ ☐
☐ ☐
☐ ☐

ANSWER

1 TRUTH

2 BULL

3 BULL
The rattling of the cans is an old superstitious practice intended to ward off evil spirits.

4 BULL

5 BULL

QUESTION

1 The actor playing George Costanza's father in Seinfeld is Ben Stiller's real dad.

Truth / Bull
☐ ☐
☐ ☐
☐ ☐
☐ ☐

2 The women of a tribe living deep inside the Amazon forest don't only nurse their children, they also breast-feed monkey babies as well. New born monkeys are taken from their mothers and treated like siblings of the human children.

Truth / Bull
☐ ☐
☐ ☐
☐ ☐
☐ ☐

3 Barbie's full name is Barbara Euphenia Heart.

Truth / Bull
☐ ☐
☐ ☐
☐ ☐
☐ ☐

4 The coffee bean is actually a fruit, not a bean.

Truth / Bull
☐ ☐
☐ ☐
☐ ☐
☐ ☐

5 New Zealand is home to a larva called a Snoddlarva. If unable to find food, the Snoddlarva eats from its own body and can survive a loss of 80% of its own body mass.

Truth / Bull
☐ ☐
☐ ☐
☐ ☐
☐ ☐

ANSWER

1 TRUTH

2 TRUTH
The tribe is called Awa Guaja.

3 BULL
Barbie's full name is Barbara Millicent Roberts.

4 TRUTH

5 BULL

QUESTION

1 A study of beggars in London showed that those with broken or missing shoes got as much as three times more money than beggars with proper shoes. It was this one component that created the largest income variation between beggars.

Truth / Bull

2 The South African version of the children's show Sesame Street stars a muppet named Kami that is HIV positive.

Truth / Bull

3 Deep Throat is the nickname of the informant in the Watergate scandal which caused President Nixon's resignation in 1974. Deep Throat communicated with his contact by raising and lowering the flag on the balcony in his office.

Truth / Bull

4 Comedian John Cleese's father changed his last name from Cheese to Cleese before World War I.

Truth / Bull

5 David Bowie's mother was an actress who once had a leading role in the TV series Neighbours.

Truth / Bull

ANSWER

1 BULL

2 TRUTH

3 BULL
Deep Throat proposed meetings with his journalist contact Bob Woodward by circling the page number and drawing clock hands on page 20 of Woodward's copy of the New York Times.

4 TRUTH

5 BULL

QUESTION

1. The word banana is derived from the Arabic word for finger.

Truth / Bull
☐ ☐
☐ ☐
☐ ☐
☐ ☐

2. Until 1996 in Utah USA, it was forbidden by law to bathe in yellow bathing suits before four o'clock in the afternoon in any lake.

Truth / Bull
☐ ☐
☐ ☐
☐ ☐
☐ ☐

3. Mount Everest is the world's highest mountain in terms of metres above sea level, but it is not the mountain with its peak furthest from the centre of the earth.

Truth / Bull
☐ ☐
☐ ☐
☐ ☐
☐ ☐

4. The Flintstones was first aired on American television in 1961. The show was intended for an adult audience and contained more risqué themes. Fred's neighbour Barney was originally named Big Balls Barney. His name was changed to Barney as the show began to attract a younger audience.

Truth / Bull
☐ ☐
☐ ☐
☐ ☐
☐ ☐

5. Instead of a tooth fairy, Bulgarian children have a tooth crow. The crow enters the child's bedroom through an open window, collects the lost tooth and leaves a cookie for the child.

Truth / Bull
☐ ☐
☐ ☐
☐ ☐
☐ ☐

ANSWER

1 TRUTH

2 BULL

3 TRUTH
The mountain peak furthest away from the centre of
the earth is Chimborazo in Ecuador.

4 BULL

5 BULL

QUESTION

1. Over 11,000 people have made a pilgrimage to New Mexico to see a tortilla crisp that appears to have Jesus' face on it.

Truth / Bull
☐ ☐
☐ ☐
☐ ☐
☐ ☐

2. Superman's alter ego Clark Kent is named after the two American actors Clark Gable and Kent Taylor.

Truth / Bull
☐ ☐
☐ ☐
☐ ☐
☐ ☐

3. Film maker Wes Anderson collects doll heads and has over 50,000 decapitated doll heads in his home.

Truth / Bull
☐ ☐
☐ ☐
☐ ☐
☐ ☐

4. Der Kluge Hans or "the smart Hans" was a German horse that lived during the late 1800s. The horse would amaze audiences by solving mathematical equations posed by his owner.

Truth / Bull
☐ ☐
☐ ☐
☐ ☐
☐ ☐

5. The small country of Andorra in the Pyrenees with just over 70,000 inhabitants has about 3 million tourists a year.

Truth / Bull
☐ ☐
☐ ☐
☐ ☐
☐ ☐

ANSWER

1 TRUTH
Unfortunately, the crisp met a cruel fate in 2006 when owner Mrs Rubio's grandchildren took it to school and dropped it.

2 TRUTH

3 BULL

4 TRUTH
However, it was later discovered that the horse couldn't actually do math, he just read the audience's reactions.

5 BULL
As many as 9 million tourists visit the microstate each year.

QUESTION

Beatle George Harrison proposed to his second wife Olivia Arias by wearing a t-shirt with the words "Marry me or bury me, Olivia!" on a British TV show.

Truth / Bull
☐ ☐
☐ ☐
☐ ☐
☐ ☐

The first Star Wars movies were made in Lanzarote.

Truth / Bull
☐ ☐
☐ ☐
☐ ☐
☐ ☐

A Canadian psychological study has shown that people who re-wallpaper or paint their home at least once every three years have better sense of direction than the average person.

Truth / Bull
☐ ☐
☐ ☐
☐ ☐
☐ ☐

Inhabitants in Lofoten in Norway have the best dental health in the world. Scientists believe it is due to the selenium rich diet and the fact that cold weather increases saliva production.

Truth / Bull
☐ ☐
☐ ☐
☐ ☐
☐ ☐

The Bible never explicitly states how many wise men were involved in the nativity story.

Truth / Bull
☐ ☐
☐ ☐
☐ ☐
☐ ☐

ANSWER

1 BULL

2 TRUTH

3 BULL

4 BULL

5 TRUTH
People assume they were three as three different types of gifts are mentioned.

QUESTION

Douglas Alexander Hamilton was a duke in the late 1700s. A very important man, Hamilton built a great mausoleum for his final resting place. He also imported an Egyptian casket said to have belonged to an Egyptian princess. When the duke finally died, his legs had to be amputated to fit inside the ill-fitting casket.

Truth / Bull

□ □
□ □
□ □
□ □

US president John F Kennedy was buried without his brain.

Truth / Bull

□ □
□ □
□ □
□ □

A cook book written around the time of Christ's birth recommends a meal made by removing the teats from a pig and filling them with fish, boiled mince, flamingo and dates.

Truth / Bull

□ □
□ □
□ □
□ □

Ladies man Casanova spent his last 13 years alive as a librarian.

Truth / Bull

□ □
□ □
□ □
□ □

The sea turtle's sharp canine teeth can grow up to ten centimetres long.

Truth / Bull

□ □
□ □
□ □
□ □

ANSWER

1 TRUTH
Adding insult to injury, it was later discovered that the casket actually longed to a simple jester, not a princess.

2 TRUTH
JFK's brain was lost during autopsy.

3 TRUTH
Roman chef Apicius recommended filled pig teats in his classic cook book from the beginning of the Common Era.

4 TRUTH

5 BULL
Turtles don't have teeth, their jaws are covered in horny ridges.

QUESTION

On average, two children are born each year with the condition known as "back foot", where one or both feet face backwards.

Truth / Bull
☐ ☐
☐ ☐
☐ ☐
☐ ☐

There is an island in Newfoundland called Dildo.

Truth / Bull
☐ ☐
☐ ☐
☐ ☐
☐ ☐

The first human to fly over the Atlantic Ocean was Charles Lindbergh.

Truth / Bull
☐ ☐
☐ ☐
☐ ☐
☐ ☐

A study has shown that pet owners glance at their wrist watches almost twice as often as those without pets.

Truth / Bull
☐ ☐
☐ ☐
☐ ☐
☐ ☐

Ticks are not insects.

Truth / Bull
☐ ☐
☐ ☐
☐ ☐
☐ ☐

ANSWER

1 BULL

2 TRUTH
The island became internationally famous when the Canadian comedy group "The Arrogant Worms" wrote the song A Night in Dildo.

3 BULL
Lindbergh was first to cross the Atlantic Ocean solo in 1927; John Alcock and Arthur Brown crossed Atlantic together in 1919.

4 BULL

5 TRUTH
Ticks are arthropods.

QUESTION

Tickling was forbidden in some countries within the former Middle East as it was thought to be an aphrodisiac.

☐ ☐
☐ ☐
☐ ☐
☐ ☐

Roman emperor Nero saved his own tears in a jar in the belief that they had healing powers. He planned to pour the tears on his first born son to make him a worthy heir.

Truth / Bull
☐ ☐
☐ ☐
☐ ☐
☐ ☐

Astronaut Buzz Aldrin was the second man on the moon. Curiously, Aldrin's mother's maiden name was Moon.

Truth / Bull
☐ ☐
☐ ☐
☐ ☐
☐ ☐

Czech woman Vera Czermak was so devastated when she found out her husband had cheated on her that she decided to kill herself. She threw herself out a third floor window but woke up a short while later. She had landed on her unfaithful husband, saving her life but killing him in the process.

Truth / Bull
☐ ☐
☐ ☐
☐ ☐
☐ ☐

In the American state of Illinois, it is forbidden by law for a widower to speak his late wife's name to his new wife during the first month of marriage.

Truth / Bull
☐ ☐
☐ ☐
☐ ☐
☐ ☐

ANSWER

1 TRUTH

2 BULL

3 TRUTH
Aldrin's mother's name was Marion Moon before she married.

4 TRUTH

5 BULL

QUESTION

A woman in San Francisco sued the city's public transport system after being hit by a tram and suffering unusual side-effects. During the first five days after the accident, the devout religious woman became a nymphomaniac and had sex with fifty different men.

Truth / Bull

☐ ☐
☐ ☐
☐ ☐
☐ ☐

It snows in Tanzania.

Truth / Bull

☐ ☐
☐ ☐
☐ ☐
☐ ☐

Two of the world's most renowned dinosaur scientists became bitter enemies after one corrected the other after he had placed the head where the behind should've been on a large dinosaur skeleton.

Truth / Bull

☐ ☐
☐ ☐
☐ ☐
☐ ☐

The first known tooth brush is believed to have been created in England in the year 500. It was made from a tree root with fish bones attached as bristles.

Truth / Bull

☐ ☐
☐ ☐
☐ ☐
☐ ☐

American jazz singer Billie Holiday took great care of her hair and used a hair mask daily that contained bullock blood and bees wax, among other things.

Truth / Bull

☐ ☐
☐ ☐
☐ ☐
☐ ☐

ANSWER

1
TRUTH
The woman was awarded damages of 50,000 dollars.

2
TRUTH
It snows on the peak of Mount Kilimanjaro, Africa's highest mountain.

3
TRUTH
Othniel Charles Marsh corrected Edward Drinker Cope on the matter. Though they hated each other after the incident, their rivalry led the two to great achievements.

4
BULL
The first tooth brush is believed to have been produced in China in the year 1400 with the stiff hairs from swine, horse and badger.

5 BULL

QUESTION

Truth / Bull

1. In the beginning of the year 2000, a Swedish-Indian science team discovered 65 million year old dinosaur excrement.

☐ ☐
☐ ☐
☐ ☐
☐ ☐

Truth / Bull

2. Queen Cleopatra ordered the decapitation of Marcus Antonius' entire harem before she married him. She put the 28 heads in alcohol and placed them at the foot of the marital bed.

☐ ☐
☐ ☐
☐ ☐
☐ ☐

Truth / Bull

3. Guinness is brewed in the African country of Sierra Leone.

☐ ☐
☐ ☐
☐ ☐
☐ ☐

Truth / Bull

4. French King Ludwig XIV was left handed and held his drinking glass in his left hand when dining. This tradition is upheld today by the French upper classes.

☐ ☐
☐ ☐
☐ ☐
☐ ☐

Truth / Bull

5. In some cultures, a glass held to toast a god was once thought too precious to be used for any other purpose. Such glasses were thus thrown against the wall and destroyed after the toast, eradicating any possibility of misuse.

☐ ☐
☐ ☐
☐ ☐
☐ ☐

ANSWER

1 TRUTH
The discovery showed that grass grew on earth 65 million years ago.

2 BULL

3 TRUTH
While most Guinness is made in Ireland, Sierra Leone was the first brewery outside of Ireland to produce the beverage.

4 BULL

5 TRUTH
The tradition found alive today in both Scandinavia and Russia.

QUESTION

1 A British survey showed that one in 25 fathers were not actually the biological parent of those they considered their children.

Truth / Bull
□ □
□ □
□ □
□ □

2 In many Finnish homes you may find mustard seeds in the shoe rack as well as on the spice rack. Mustard seeds have long been used as a deodoriser in Finland.

Truth / Bull
□ □
□ □
□ □
□ □

3 Chess boxing is a sport in which two contestants play chess and box alternately in a boxing ring. It is possible to win by checkmate or by knockout.

Truth / Bull
□ □
□ □
□ □
□ □

4 Polar bears are left handed.

Truth / Bull
□ □
□ □
□ □
□ □

5 An oyster's eye is bigger than its brain.

Truth / Bull
□ □
□ □
□ □
□ □

ANSWER

1 TRUTH

2 BULL

3 TRUTH
The first chess boxing match was held in 2003.
Berlin is home to a specialist chess boxing gym.

4 TRUTH
Scientists have observed that polar bears prefer to
use the left hand when they club seals or pluck them
out of the water.

5 TRUTH

QUESTION

Truth / Bull

1 Leonardo da Vinci invented scissors.

☐ ☐
☐ ☐
☐ ☐
☐ ☐

Truth / Bull

2 Two brothers in India made headlines after both were born with seven fingers on each hand and seven toes on each foot.

☐ ☐
☐ ☐
☐ ☐
☐ ☐

Truth / Bull

3 The official language of Estonia is Estonian.

☐ ☐
☐ ☐
☐ ☐
☐ ☐

Truth / Bull

4 The Former American President George W. Bush said in a speech during his first visit to Africa in 2001: "Rich people not only are richer, but also a lot better looking than the less fortunate, I have noticed during my travelling".

☐ ☐
☐ ☐
☐ ☐
☐ ☐

Truth / Bull

5 If you sleep more than ten hours per night, your risk of developing schizophrenia increases.

☐ ☐
☐ ☐
☐ ☐
☐ ☐

ANSWER

1 TRUTH

2 BULL
However, there are two brothers in India who each have
six fingers on each hand and six toes on each foot.

3 TRUTH

4 BULL

5 BULL

QUESTION

Truth / Bull

1 Up to 80% of American men are circumcised.
☐ ☐
☐ ☐
☐ ☐
☐ ☐

Truth / Bull

2 The largest compact poo ever weighed came from a German man named Helmut Kahn. It weighed 8 kilos and was over 32 centimetres long.
☐ ☐
☐ ☐
☐ ☐
☐ ☐

Truth / Bull

3 The shortest war ever fought was between Zanzibar and Great Britain and lasted 38 minutes.
☐ ☐
☐ ☐
☐ ☐
☐ ☐

Truth / Bull

4 Horses can't vomit.
☐ ☐
☐ ☐
☐ ☐
☐ ☐

Truth / Bull

5 The world's second most common name is Mohammed.
☐ ☐
☐ ☐
☐ ☐
☐ ☐

ANSWER

1

TRUTH
In Australia 70% of men are circumcised and in England, 24% are circumcised. Circumcision is hardly ever performed in Scandinavia where it has even been argued that the practice should be viewed as child abuse.

2

BULL

3

TRUTH
The war was fought in 1896 when Zanzibar was a British protectorate. Trouble arose when the British refused to acknowledge the new sultan of Zanzibar. The war started at nine in the morning and ended before 9.40am. The British, who one an easy victory, forced the local population to pay for the ammunition that was spent during the short war.

4

TRUTH

5

BULL
Mohammed is the most common name in the world.

QUESTION

Truth / Bull

In 1991 a study was published proving that right handed people live an average of nine years longer than left handed people.

☐ ☐
☐ ☐
☐ ☐
☐ ☐

Truth / Bull

According to German scientists, the risk of heart attack is higher on Mondays than on other days of the week.

☐ ☐
☐ ☐
☐ ☐
☐ ☐

Truth / Bull

Shania Twain uses the phrase "I'm better than that" in some form in all the singles from her first three albums. The phrase has become a kind of mantra for Shania and she also sometimes uses it in interviews.

☐ ☐
☐ ☐
☐ ☐
☐ ☐

Truth / Bull

When a crown prince is born in the Sultanate of Oman, the entire nation participates in a three-day fast. No one is allowed to eat solid foods during daytime in honour of the baby who can only ingest liquids. This is done to show Allah how much the new child means to the people.

☐ ☐
☐ ☐
☐ ☐
☐ ☐

Truth / Bull

Austria is home to the world's first divorce fair. At the fair, couples with divorce plans can get advice from divorce lawyers about their rights and obligations related or listen to lectures about how children are affected by divorce.

☐ ☐
☐ ☐
☐ ☐
☐ ☐

ANSWER

1 TRUTH
According to the findings, left handed people more often are involved in accidents, due to their left handedness in a world where most machines and tools are made for right handed people.

2 TRUTH

3 BULL

4 BULL

5 TRUTH

QUESTION

Truth / Bull

1 In old sailor parlance, a "motherless ship" denotes a ship or boat without lanterns.

☐ ☐
☐ ☐
☐ ☐
☐ ☐

Truth / Bull

2 Actress Natalie Portman speaks fluent Hebrew.

☐ ☐
☐ ☐
☐ ☐
☐ ☐

Truth / Bull

3 The heaviest pike ever caught weighed 75.4 kilos.

☐ ☐
☐ ☐
☐ ☐
☐ ☐

Truth / Bull

4 The man behind The Muppets Show character's movements and voices, Frank Oz, was also the voice of Yoda in Star Wars.

☐ ☐
☐ ☐
☐ ☐
☐ ☐

Truth / Bull

5 The Manhattan cocktail was invented by Winston Churchill's mother, Jennie Jerome.

☐ ☐
☐ ☐
☐ ☐
☐ ☐

ANSWER

1 BULL

2 TRUTH
Natalie Portman was born in Jerusalem and moved to the USA as a three-year-old.

3 BULL
The heaviest pike ever caught actually weighed 25 kilos. According to the Guinness Book of Records, German Lothar Louis caught the record-breaking pike in 1986.

4 TRUTH

5 TRUTH

QUESTION

Rice is the most common crop grown on earth.

Truth / Bull
☐ ☐
☐ ☐
☐ ☐
☐ ☐

The world's most expensive pair of jeans so far was sold on eBay in 2005 for US$60,000 dollars.

Truth / Bull
☐ ☐
☐ ☐
☐ ☐
☐ ☐

In 2003, Australian man Peter Baulman had a kidney stone removed that weighed 3.6 kilos and measured close to 12 centimetres in length.

Truth / Bull
☐ ☐
☐ ☐
☐ ☐
☐ ☐

John Cleese was chairman of the "Nessie is Real" organisation from 1981–1984. Founded in 1965, the group is dedicated to gathering evidence supporting the existence of the Loch Ness monster. Though no longer the chairman, Cleese is still an active member.

Truth / Bull
☐ ☐
☐ ☐
☐ ☐
☐ ☐

The heaviest hammerhead shark ever caught weighed more than half a ton.

Truth / Bull
☐ ☐
☐ ☐
☐ ☐
☐ ☐

ANSWER

1 BULL
Corn is the most common crop with 600 million tons being harvested each year.

2 TRUTH
A Japanese collector bought the 115-year-old original Levi 501 jeans.

3 TRUTH
Peter made it into the Guinness Book of Records for this painful accomplishment.

4 BULL

5 TRUTH
American Bucky Dennis caught the record fish, weighing a total of 580 kilograms and 59 grams.

QUESTION

Typical working ants don't live longer than two weeks.

Truth / Bull

☐ ☐
☐ ☐
☐ ☐
☐ ☐

The capital of Samoa is called Granny.

Truth / Bull

☐ ☐
☐ ☐
☐ ☐
☐ ☐

French writer Alexandre Dumas (author of The Three Musketeers) is the illegitimate son of another great French writer, Jules Verne who wrote Around the World in Eighty Days and Twenty Thousand Leagues Under the Sea.

Truth / Bull

☐ ☐
☐ ☐
☐ ☐
☐ ☐

A Kalashnikov automatic rifle is depicted on the flag of Mozambique.

Truth / Bull

☐ ☐
☐ ☐
☐ ☐
☐ ☐

Italian doctor Gabriel Fallopius was the inventor of the condom. His condom from the year 1564 was practically a thin, stiff piece of linen to be wind around the penis.

Truth / Bull

☐ ☐
☐ ☐
☐ ☐
☐ ☐

ANSWER

1

BULL
They live for up to six months.

2

BULL
Apia is the capital of Samoa. It has a population of approximately 40,400 inhabitants and is located on the island of Upolu in the southwest pacific.

3

BULL

4

TRUTH
The weapon symbolises the country's fight for independence.

5

TRUTH
Fallopius' condom was designed to protect men from venereal diseases rather than to prevent pregnancy. Around this time, pregnancy was viewed as a strictly female issue. As well as the condom, Gabriel Fallopius is famous for his work on the skeleton and the composition of the hearing organs.

QUESTION

Albion is the first known name for Great Britain.

☐ ☐
☐ ☐
☐ ☐
☐ ☐

The Padang people in Northern Thailand completely shave the body of the dead before burial. The nails are also pulled off the fingers and toes, to make the deceased as clean as possible before they meet the gods.

Truth / Bull

☐ ☐
☐ ☐
☐ ☐
☐ ☐

The island group Micronesia was so named because its inhabitants were on average fifteen centimetres shorter than the world population.

Truth / Bull

☐ ☐
☐ ☐
☐ ☐
☐ ☐

Magnetic levitation is the technique used to keep objects levitating using magnetic force.

Truth / Bull

☐ ☐
☐ ☐
☐ ☐
☐ ☐

Beef Stroganoff is named after the Russian count Stroganov who, during the 1700s, asked his chef to cut the meat into smaller pieces due to his lack of teeth.

Truth / Bull

☐ ☐
☐ ☐
☐ ☐
☐ ☐

ANSWER

1 TRUTH
The name Albion derives from an old Indo-European language and refers to the white cliffs of Dover.

2 BULL

3 BULL
Micronesia means "small islands".

4 TRUTH
There is a 3 mile long railway between Shanghai and the Pudong airport where the technique is used. The train levitates 15 millimetres over the tracks and reaches a top speed of 430 km/h before arriving at the airport seven minutes later.

5 TRUTH

QUESTION

Actor John Stamos was once part of the pop group the Beach Boys.

Truth / Bull
□ □
□ □
□ □
□ □

A cockroach can live without a head for up to a week as it doesn't breathe through its mouth or bleed very much.

Truth / Bull
□ □
□ □
□ □
□ □

Actor Harry Hemlin, mostly known for his part as Michael Kuzak in the TV show L.A. Law, was arrested for the double murder of his Los Angeles neighbours in 1992. Harry was released after two and a half weeks when the real murderer was caught. The Los Angeles police gave their official apology and Harry was paid a high sum of damages.

Truth / Bull
□ □
□ □
□ □
□ □

Australia has the highest number of wild camels in the world.

Truth / Bull
□ □
□ □
□ □
□ □

For a war to be called a "world war", at least twelve countries must be involved.

Truth / Bull
□ □
□ □
□ □
□ □

ANSWER

1

TRUTH
John played the drums with the Beach Boys and participated in the recording of the single Kokomo.

2

TRUTH
Although, after a week without a head, a cockroach would starve to death.

3

BULL

4

TRUTH
By the end of the 19th century, about 10,000 camels had been imported to Australia as a mode of transport. When they were no longer needed, the camels were released into the wild. There are over a quarter of a million wild camels in Australia today.

5

BULL
A war is termed a "world war" if it is fought on more than one continent and involves global conflict. No specific number of countries need be involved.

QUESTION

Truth / Bull

1. Dionysius Thrax was the original name for the dinosaur Tyrannosaurus Rex. The name was changed when it was discovered that the dinosaur walked on two legs (rex) instead of four (thrax).

☐ ☐
☐ ☐
☐ ☐
☐ ☐

Truth / Bull

2. The bones that whales use to filter water from plankton were once used in the production of parasols and corsets.

☐ ☐
☐ ☐
☐ ☐
☐ ☐

Truth / Bull

3. The ex 'N sync member Lance Bass is a cosmonaut in Russia.

☐ ☐
☐ ☐
☐ ☐
☐ ☐

Truth / Bull

4. At the end of the 1950s, China's leader Mao Zedong ordered all sparrows to be exterminated.

☐ ☐
☐ ☐
☐ ☐
☐ ☐

Truth / Bull

5. The leaves of a regular potato are poisonous.

☐ ☐
☐ ☐
☐ ☐
☐ ☐

ANSWER

1 BULL
Dionysius Thrax was the name of the man who coined word groups such as pronouns, articles, verbs and adverbs among others.

2 TRUTH

3 TRUTH
Although, he never got to go into space.

4 TRUTH
Mao Zedong declared the sparrows were a natural plague that had to be exterminated. It is said that up to 18 million sparrows were killed before scientists convinced Mao the birds played an important role eating insects.

5 TRUTH
All green parts of the potato contain the alkaloid solanin which is a nerve toxin.

QUESTION

1 The world's largest statue can be found in the small Belarus town of Pinsk. The statue depicts the formed Soviet leader Leonid Breznjev and weighs over 180 tons.

Truth / Bull
☐ ☐
☐ ☐
☐ ☐
☐ ☐

2 The Greek national anthem is over 158 verses long.

Truth / Bull
☐ ☐
☐ ☐
☐ ☐
☐ ☐

3 The longest ears ever measured on a rabbit are 65 centimetres long.

Truth / Bull
☐ ☐
☐ ☐
☐ ☐
☐ ☐

4 The "Mexican wave" (when an audience creates a wave around an arena by standing up and sitting down) actually comes from Brazil where it started in the 1940s.

Truth / Bull
☐ ☐
☐ ☐
☐ ☐
☐ ☐

5 The highest jump ever measured by a pig was in Japan in 2004. A pig named Kotetsu managed to jump 1 metre and 40 centimetres.

Truth / Bull
☐ ☐
☐ ☐
☐ ☐
☐ ☐

ANSWER

1
BULL
The world's largest statue is said to be the Russian statue "Motherland" that weighs 5500 tons.

2
BULL
The anthem comprises two verses taken from a 158 verse poem.

3
BULL
An American rabbit named Nipper had 79 centimetre long ears.

4
BULL
No one knows where "the wave" originated, but American sources claim it first occurred during American football games in the 1970s. The wave's world breakthrough came at the soccer world championship in Mexico in 1986.

5
BULL
Kotetsu does hold the world record for the highest jump by a pig, but his jump was actually 70cm high.

QUESTION

Prince Radian was a great performer during the last turn of the century. Radian was born without arms or legs and was known as "the living torso". His show included him shaving, writing and rolling cigarettes – all without arms and legs.

Truth / Bull
□ □
□ □
□ □
□ □

Dermatitis Speculum or the "mirror disease" is the phobia of your own reflection. Oscar Wilde was a known sufferer of the mirror disease.

Truth / Bull
□ □
□ □
□ □
□ □

As coffee supplies ran short during World War II, alternative ingredients such as roasted and ground figs were used.

Truth / Bull
□ □
□ □
□ □
□ □

In the first century AD, Norwegian currency included solid, ruler shaped money with particular perforations. The money could be broken off at each perforation according to the amount required.

Truth / Bull
□ □
□ □
□ □
□ □

The only beardless member in the band ZZ top has the last name of Beard.

Truth / Bull
□ □
□ □
□ □
□ □

ANSWER

1 TRUTH

2 BULL

3 TRUTH

4 BULL

5 TRUTH

QUESTION

Anthropophagy is another word for cannibalism.

Truth / Bull
☐ ☐
☐ ☐
☐ ☐
☐ ☐

A German study has shown that people who use public transportation regularly contract influenza three times more often than people who use their own car.

Truth / Bull
☐ ☐
☐ ☐
☐ ☐
☐ ☐

Dental healthcare brand Colgate was founded in 1806 and sold diaphragms up until the middle of 1900.

Truth / Bull
☐ ☐
☐ ☐
☐ ☐
☐ ☐

The Chinese pseudoscience Feng Shui has been adopted worldwide as a way of creating more pleasant homes. However, Feng Shui actually translates to chaos and stone.

Truth / Bull
☐ ☐
☐ ☐
☐ ☐
☐ ☐

The box jellyfish is one of the most poisonous creatures in the world.

Truth / Bull
☐ ☐
☐ ☐
☐ ☐
☐ ☐

ANSWER

1 TRUTH

2 BULL

3 BULL

4 BULL
Feng Shui means wind and water.

5 TRUTH
A sting from a box jellyfish can cause death within minutes.

QUESTION

A Liberian boy named Emmanuel Johnson Jr, was born without an anus.

Truth / Bull
☐ ☐
☐ ☐
☐ ☐
☐ ☐

A survey of brutal criminals in Australia showed that over 30 percent of serial killers were born in the sign of Sagittarius.

Truth / Bull
☐ ☐
☐ ☐
☐ ☐
☐ ☐

Actor Larry Hagman who played the alcoholic character of JR Ewing in Dallas was actually a teetotaller. Though his character constantly had a glass in his hand, Hagman had never even tasted alcohol.

Truth / Bull
☐ ☐
☐ ☐
☐ ☐
☐ ☐

Hypertrichosis is an unusual condition that causes hair growth in strange places. Sufferers may grow hair on their palms or forehead.

Truth / Bull
☐ ☐
☐ ☐
☐ ☐
☐ ☐

The Romans used to bury the dead naked, with a small knife and a piece of bread.

Truth / Bull
☐ ☐
☐ ☐
☐ ☐
☐ ☐

ANSWER

1

TRUTH
Little Emmanuel had to travel to Minnesota for surgery. One in 5000 people are born without an anus.

2

BULL

3

BULL
Larry Hagman had similar drinking habits to his character JR Ewing. Hagman drank three bottles of champagne and six cocktails every day during his thirteen years on Dallas. Hagman had a liver transplant in 1995 as a direct result of his excessive alcohol consumption.

4

TRUTH
Extreme cases may result in hair growth over the entire face except for the eyes and mouth.

5

BULL

QUESTION

The first animal in space was a dog named Laika, who was sent up in a Soviet rocket in 1957. Six years later, a French cat named Feliette made the same journey.

Truth / Bull
☐ ☐
☐ ☐
☐ ☐
☐ ☐

Clint Eastwood is not only an actor and director, but also a musician. He even co-wrote the music for The Bridges of Madison County.

Truth / Bull
☐ ☐
☐ ☐
☐ ☐
☐ ☐

Bram Stoker's novel Dracula was based on the story of Vlad Tepes who ruled Romania during the first half of the 15th century.

Truth / Bull
☐ ☐
☐ ☐
☐ ☐
☐ ☐

The rum cocktail known as a Mojito received its name from the Cuban island of the same name. "Mojito" means "small green" in Spanish.

Truth / Bull
☐ ☐
☐ ☐
☐ ☐
☐ ☐

Samurai sudoku is an extra hard version of sudoku that consists of many overlapping sudoku squares.

Truth / Bull
☐ ☐
☐ ☐
☐ ☐
☐ ☐

ANSWER

1 TRUTH

2 TRUTH
Clint has co-written many movie soundtracks.

3 TRUTH
Vlad Tepes was the son of sovereign Vlad Dracul and was called Dracula which is Romanian for "the dragon's son" or "the Devil's son". Both father and son were (according to stories) cruel rulers.

4 BULL
There is no island called Mojito.

5 TRUTH

QUESTION

Truth / Bull

1 The first air balloon voyage was made in 1783. The passengers were a sheep, a rooster and a duck. All three animals made it home unharmed.

☐ ☐
☐ ☐
☐ ☐
☐ ☐

Truth / Bull

2 The Hebrew alphabet is also used in Yiddish and Jewish Arabic writing.

☐ ☐
☐ ☐
☐ ☐
☐ ☐

Truth / Bull

3 The first woman in space made her pioneering journey on the 16th of June, 1983.

☐ ☐
☐ ☐
☐ ☐
☐ ☐

Truth / Bull

4 A vacuum cleaner salesman named Jamie Howard knocked on Paul Sucher's door in Idaho, hoping to sell the man a vacuum cleaner. As their conversation progressed, Jamie forgot about his vacuum cleaner, instead promising to donate one of his kidneys to the desperately ill customer – a promise he later delivered.

☐ ☐
☐ ☐
☐ ☐
☐ ☐

Truth / Bull

5 Statue crushing was a method of execution that was used up until the 1980s in the United Arab Emirates. The prisoner was forced to position themselves at the foot of a statue that was then tipped over, crushing the victim to death.

☐ ☐
☐ ☐
☐ ☐
☐ ☐

ANSWER

1 TRUTH

2 TRUTH

3 BULL
Valentina Teresjkova became the first woman to go to space in 1963.

4 BULL

5 TRUTH
Statue crushing was a method of execution that was used up until the 1980s in the United Arab Emirates. The prisoner was forced to position themselves at the foot of a statue that was then tipped over, crushing the victim to death.

QUESTION

Truth / Bull

1. Austrian Theodore Climm invented a nutritional supplement in 1986 known as Riasac. When eaten on a regular basis, Riasac would allow humans to digest grass the same way cattle can. Despite the potential this supplement has to erase starvation throughout the world, it hasn't had any commercial success due to high manufacturing costs.

☐ ☐
☐ ☐
☐ ☐
☐ ☐

Truth / Bull

2. NASA has developed a bag that affects the molecular structure of what is packed inside. Any item placed inside the bag becomes marginally lighter. Up until now the weight difference has been negligible but researchers maintain that the bag will eventually be able to reduce the weight of any item by up to ten percent.

☐ ☐
☐ ☐
☐ ☐
☐ ☐

Truth / Bull

3. Director Steven Spielberg has received the most Oscar nominations of any person alive today.

☐ ☐
☐ ☐
☐ ☐
☐ ☐

Truth / Bull

4. The word "huckster" is American slang for a heroin addict.

☐ ☐
☐ ☐
☐ ☐
☐ ☐

Truth / Bull

5. The world's heaviest lemon was picked in Israel in 2003. It weighed 5.2 kilos.

☐ ☐
☐ ☐
☐ ☐
☐ ☐

ANSWER

1 BULL

2 BULL

3 BULL
Composer John Williams has received the most nominations
–a whopping 41 all in all. He has won five times.

4 BULL
Huckster is used when talking about people in the
advertising or sales industries.

5 TRUTH

QUESTION

1. Demi Moore hired a three-person camera crew to film the birth of her first baby.

Truth / Bull
☐ ☐
☐ ☐
☐ ☐
☐ ☐

2. Russian Vladimir Demikhov shocked the world when he created a two-headed dog in 1954. Vladimir performed the cruel surgery himself, fusing an adult German shepherd with a puppy. Neither dog lived for long.

Truth / Bull
☐ ☐
☐ ☐
☐ ☐
☐ ☐

3. As well as white swans and black swans, a breed called black necked swans also exists. These swans are characterised by their white bodies and black necks.

Truth / Bull
☐ ☐
☐ ☐
☐ ☐
☐ ☐

4. Radhakant Bajpai of Naya Ganj, Uttar Pradesh in India has the world's longest ear hair. It is 13.2 centimetres long.

Truth / Bull
☐ ☐
☐ ☐
☐ ☐
☐ ☐

5. Actor Jake Gyllenhaal worked as a lifeguard before his acting career took off. He once urinated on a man who had been stung by a jellyfish.

Truth / Bull
☐ ☐
☐ ☐
☐ ☐
☐ ☐

ANSWER

1 TRUTH

2 TRUTH
Vladimir created twenty something two-headed dogs, none of whom lived more than a month.

3 TRUTH
The Black necked swans live in South America.

4 TRUTH
When Radhakant Bajpai was admitted into the Guinness Book of World Records for his lengthy ear hair, he said: "God has been very kind to me".

5 TRUTH

QUESTION

1 Tom Cruise's very first acting job was as Snakeboy in the movie Tunnel of Death. Tom was only 6 years old.

Truth / Bull
☐ ☐
☐ ☐
☐ ☐
☐ ☐

2 The first insect to be sent into space in a spaceship was a fruit fly.

Truth / Bull
☐ ☐
☐ ☐
☐ ☐
☐ ☐

3 In 1962 American scientists wanted to see the effect LSD had on elephants. They injected nearly 300 milligrams of LSD into an elephant's buttocks (3000 times the usual human dose) and within one hour, the elephant died.

Truth / Bull
☐ ☐
☐ ☐
☐ ☐
☐ ☐

4 The name of the Hawaiian capital Honolulu means "white sea shell".

Truth / Bull
☐ ☐
☐ ☐
☐ ☐
☐ ☐

5 Even though all piranhas have sharp teeth and strong jaws, some of them are actually vegetarians.

Truth / Bull
☐ ☐
☐ ☐
☐ ☐
☐ ☐

ANSWER

1 BULL

2 TRUTH

3 TRUTH
The scientists' conclusion was that elephants
are very sensitive to LSD.

4 BULL
Honolulu means "protected bay".

5 TRUTH

QUESTION

1 Yulunggul is a Korean coffee-drink that consists of, besides coffee, orange liqueur and ground nutmeg. The drink was peaked in popularity in the 1970's but is now enjoying a comeback in Korean coffee-bars.

Truth / Bull
☐ ☐
☐ ☐
☐ ☐
☐ ☐

2 A "crore" is an Indian man or woman who gives half their income to charity. This is not unusual among practicing Hindus.

Truth / Bull
☐ ☐
☐ ☐
☐ ☐
☐ ☐

3 The American battery manufacturer Duracell has stopped using their pink Duracell rabbit in TV commercials in Germany after a series of porn-movies were made featuring a similar pink rabbit.

Truth / Bull
☐ ☐
☐ ☐
☐ ☐
☐ ☐

4 American Steven Petrosino once drank a litre of beer in 1.3 seconds.

Truth / Bull
☐ ☐
☐ ☐
☐ ☐
☐ ☐

5 The Pope has a full time personal tailor called a "Stavenelli". Only a true "Stavenelli" is permitted to make the Pope's traditional robes.

Truth / Bull
☐ ☐
☐ ☐
☐ ☐
☐ ☐

ANSWER

1 BULL
Yulunggul is a great python in Australian
Aboriginal mythology.

2 BULL
Crore is an Indian and Persian a method of calculation.

3 BULL

4 TRUTH
Steven set the beer swilling record in 1992. According
to the Guinness Book of Records, Steven is also a mem-
ber of Mensa, flies attack helicopters for the US Army
and has a black belt in Taekwondo.

5 BULL

QUESTION

Actor Kevin Spacey has a variety of magnolia named after him. The extremely unusual flower was discovered on the same day American Beauty premiered in the United States, and has now been given the name the Spacey magnolia.

Truth / Bull

☐ ☐
☐ ☐
☐ ☐
☐ ☐

Malawi women are not allowed to cut their hair without their husband's permission.

Truth / Bull

☐ ☐
☐ ☐
☐ ☐
☐ ☐

In 2006, Texas governor Rick Perry put forward a proposal to delete the date September 11th from the calendar.

Truth / Bull

☐ ☐
☐ ☐
☐ ☐
☐ ☐

A "genderfender" is a dummy for transsexual women to use as a penis substitution. The "genderfender" got its name from its boat fender like shape.

Truth / Bull

☐ ☐
☐ ☐
☐ ☐
☐ ☐

One of the lesser known of Leonardo da Vinci's theories was that different elements had different genders. He divided the elements of air, water, earth and fire into male, female and bi-gender categories.

Truth / Bull

☐ ☐
☐ ☐
☐ ☐
☐ ☐

ANSWER

1 BULL

2 BULL

3 BULL

4 BULL

5 BULL

QUESTION

Truth / Bull

The prime minister of Spain, José Luis Rodriguez Zapatero, officially offended the feminist movement with the following quote: "There are only two kinds of women: goddesses and doormats".

☐ ☐
☐ ☐
☐ ☐
☐ ☐

Truth / Bull

Whoopi Goldberg's uncle died when a slot machine fell on him after he had shaken it to get the stuck coins out of the slot.

☐ ☐
☐ ☐
☐ ☐
☐ ☐

Truth / Bull

Walt Disney banned employees of his amusement parks from having moustaches. The ban was imposed in 1957 and was only lifted in 2000.

☐ ☐
☐ ☐
☐ ☐
☐ ☐

Truth / Bull

During the middle ages in southern Europe, an aphrodisiac was made from ground finger nails. Men were also encouraged to bite their nails to combat potency issues.

☐ ☐
☐ ☐
☐ ☐
☐ ☐

Truth / Bull

George Clooney was born in the city of Christmas in Florida and was known as George Christmas before his career took off.

☐ ☐
☐ ☐
☐ ☐
☐ ☐

ANSWER

1 BULL
This controversial statement is said
to have been made by Picasso.

2 BULL

3 TRUTH
Walt Disney enforced the ban despite the fact
that he sported a moustache himself.

4 BULL

5 BULL
George Clooney was born in Lexington, Kentucky
and has always used his real name.

QUESTION

There is a species of fish around the equator called surgeonfish named for the sharp, scalpel like spine placed on its tail.

Truth / Bull
☐ ☐
☐ ☐
☐ ☐
☐ ☐

Sveti Jurij is one of Slovenia's most popular singers. Sveti sings covers of Madonna's songs translated into Slovenian.

Truth / Bull
☐ ☐
☐ ☐
☐ ☐
☐ ☐

Sufferers of an unusual genetic defect called Trimethylaminuria live with the unfortunate symptom of omitting an unpleasant fish-like odour.

Truth / Bull
☐ ☐
☐ ☐
☐ ☐
☐ ☐

According to Nordic mythology, the deceased must not enter the kingdom of the dead barefoot. As such, families traditionally buried the deceased with firmly tied shoes.

Truth / Bull
☐ ☐
☐ ☐
☐ ☐
☐ ☐

Entomologists in Argentina issued a warning last year after they discovered that a certain cockroach had increased in size by six percent in the last fifteen years. Scientists are fearful of the cockroach's potential impact on the ecological system, but are more concerned that the insect (if it continues to grow at the same rapid pace) will weigh 150 pounds within 300 years and therefore become a real threat to humans.

Truth / Bull
☐ ☐
☐ ☐
☐ ☐
☐ ☐

ANSWER

1 TRUTH

2 BULL
 Sveti Jurij is a region in Slovenia.

3 TRUTH
 Approximately 600 people around the world suffer from this
 disease. There is no treatment, though sufferers may re-
 duce the smell by avoiding foods containing chorine such as
 fish, eggs and some meat.

4 TRUTH
 They used so called Hel-shoes named after Hel, the
 daughter of Loke, who reigned over the dead.

5 BULL

QUESTION

A South Korean nuclear power plant was forced to close in May of 2001 when the cooling system became overrun with rats.

Truth / Bull

□ □
□ □
□ □
□ □

A study by the German Sexual Information Organisation (SIO) shows that both animals and humans are more easily aroused during cloudy or overcast weather.

Truth / Bull

□ □
□ □
□ □
□ □

In the Nordic Viking clan of Frejdaur, it was considered an act of love to close your lips around a small boil or pimple on your beloved's body, then suck out the content and swallow.

Truth / Bull

□ □
□ □
□ □
□ □

Men in some African tribes avoid impregnating a woman by sitting on sun heated rocks before having sex.

Truth / Bull

□ □
□ □
□ □
□ □

Studies show that when Sweden is successful in sports, Swedes tend to have more sex. According to research, the nation's sporting success triggers the population's collective libido.

Truth / Bull

□ □
□ □
□ □
□ □

ANSWER

1

BULL
It was shrimps rather than rats that forced the plant to close.

2

BULL

3

BULL

4

TRUTH
To create an optimal environment for healthy sperm, a man's testicles must be kept cool. As such, some African tribesmen believe heating the testicles to be a method of contraception.

5

TRUTH
Research actually shows that 30 percent of Swedes are more in the mood for sex when the country's football team has done well.

QUESTION

A 19th century tradition among the Adakki-people of Bali required every man with intentions to marry a woman was to have sex with the bride's mother before the wedding, in order to be accepted as a groom.

Truth / Bull
☐ ☐
☐ ☐
☐ ☐
☐ ☐

A giraffe can stretch out his tongue to almost half a meter.

Truth / Bull
☐ ☐
☐ ☐
☐ ☐
☐ ☐

The Great Wall of China is visible from the moon.

Truth / Bull
☐ ☐
☐ ☐
☐ ☐
☐ ☐

If you pour mustard powder into a glass of red wine, the wine will turn yellow.

Truth / Bull
☐ ☐
☐ ☐
☐ ☐
☐ ☐

The Great Dane is the world's largest breed of dog.

Truth / Bull
☐ ☐
☐ ☐
☐ ☐
☐ ☐

ANSWER

1 BULL

2 TRUTH

3 BULL
No details of Earth's surface can be seen from the moon.

4 BULL

5 BULL
The Irish wolfhound is bigger and can weigh up to 85 kg.

QUESTION

Truth / Bull

1. According to a British study, women surrounded mostly by men, have more frequent ovulation than women more commonly surrounded by other women.

☐ ☐
☐ ☐
☐ ☐
☐ ☐

Truth / Bull

2. When Thomas Edison died in 1931, the inventor of the light bulb was honoured by a dark minute in which all the lights throughout the United States were turned off.

☐ ☐
☐ ☐
☐ ☐
☐ ☐

Truth / Bull

3. The abbreviated language used in online environments (such as writing "LOL" to denote "laughing out loud" is known as "leet" – taken from the word elite.

☐ ☐
☐ ☐
☐ ☐
☐ ☐

Truth / Bull

4. When Mao Tse Tung took power in China, he banned the use of opium. As a result, heroin use throughout the rest of Asia increased dramatically during this period.

☐ ☐
☐ ☐
☐ ☐
☐ ☐

Truth / Bull

5. The magic formula "Hocus Pocus" is derived from word of the Holy Communion.

☐ ☐
☐ ☐
☐ ☐
☐ ☐

ANSWER

1 BULL

2 TRUTH

3 TRUTH

4 TRUTH

5 TRUTH
The Latin phrases "hoc est enim corpus meum" and "flioque"
were sometimes used by magicians during the 17th century
to denote something incomprehensible and miraculous.

QUESTION

Truth / Bull

1 In Japan, a deck of cards is a common gift for five-year-olds.

☐ ☐
☐ ☐
☐ ☐
☐ ☐

Truth / Bull

2 Actor Johnny Depp was 22 when he appeared in the movie Edward Scissorhands.

☐ ☐
☐ ☐
☐ ☐
☐ ☐

Truth / Bull

3 Tintin's dog Snowy is called Terry in Danish.

☐ ☐
☐ ☐
☐ ☐
☐ ☐

Truth / Bull

4 In France and Italy, women didn't have the right to vote until after the World War II, in 1945.

☐ ☐
☐ ☐
☐ ☐
☐ ☐

Truth / Bull

5 The Norse god Balder was killed by a hatchet.

☐ ☐
☐ ☐
☐ ☐
☐ ☐

ANSWER

1 BULL

2 BULL
He was 27 at the time.

3 TRUTH

4 TRUTH

5 BULL
The only thing that could and did kill
Balder was mistletoe.

QUESTION

Water is element number 25 in the periodic table.

Truth / Bull
☐ ☐
☐ ☐
☐ ☐
☐ ☐

The Lord of the Rings actor Viggo Mortensen worked as a translator for the Swedish hockey team during the 1980 Olympic Games.

Truth / Bull
☐ ☐
☐ ☐
☐ ☐
☐ ☐

It's obligatory for all soldiers in the Brazilian military to be able to stand on their hands.

Truth / Bull
☐ ☐
☐ ☐
☐ ☐
☐ ☐

In the Disney movie Snow White, the seven dwarfs worked in a gold mine.

Truth / Bull
☐ ☐
☐ ☐
☐ ☐
☐ ☐

Charlie Chaplin never received an Oscar.

Truth / Bull
☐ ☐
☐ ☐
☐ ☐
☐ ☐

ANSWER

1 BULL
Water is not an element in the periodic table, it is composed of the two elements hydrogen and oxygen.

2 TRUTH

3 BULL

4 BULL
They worked in a diamond mine.

5 BULL
He received three Oscars: in 1927, 1972 and in 1973.

QUESTION

Truth / Bull

During his administration, former American president Ronald Reagan named the third Sunday in July "National Ice Cream Day".

☐ ☐
☐ ☐
☐ ☐
☐ ☐

Truth / Bull

One of Donald Sutherland's main characters in a movie was once called Homer Simpson.

☐ ☐
☐ ☐
☐ ☐
☐ ☐

Truth / Bull

Since 1999, the Danish government has taken strong measures to cope with the problems of public masturbation. Special guards and alarms have been installed around the major cities in Denmark.

☐ ☐
☐ ☐
☐ ☐
☐ ☐

Truth / Bull

Among the AKA-pygmies in the Congo, newborn babies often suck on their father's nipple. New parents use the technique to calm the baby down.

☐ ☐
☐ ☐
☐ ☐
☐ ☐

Truth / Bull

Now a vital element in most playgrounds, the sandbox (or sandpit) was first designed for cats as a giant litter box. The boxes were placed in residential areas to eliminate the problem of animal waste. The sandpits quickly became more popular with children than with the neighbourhood cats.

☐ ☐
☐ ☐
☐ ☐
☐ ☐

ANSWER

1 TRUTH

2 TRUTH
In the 1975 movie The Last Days of Locust, Donald plays a character named Homer Simpson.

3 BULL

4 TRUTH

5 BULL

QUESTION

The character Indiana Jones is named after Harrison Ford's dog.

Truth / Bull

The second Saturday in September is a special harvest holiday in Holland when children throw tomatoes and bread buns at a man dressed up as a crow.

Truth / Bull

The computer game "Pacman" was designed in the likeness of a pizza with one slice missing.

Truth / Bull

The Dalmatian dog breed is named after the Croatian city of Dalmatia.

Truth / Bull

The first AA (Alcoholics Anonymous) meeting took place in 1935.

Truth / Bull

ANSWER

1 BULL
Indiana Jones is named after director George Lucas' dog.

2 BULL

3 TRUTH
It is said that the inventor of the game, Toru Iwatani, came up with the idea in a pizzeria.

4 TRUTH
The spotty dog took its name from this city in the 18th century.

5 TRUTH
The meeting was held in the United States on May 12 in 1935, organized by two alcoholics.

QUESTION

1 The name of the Durex brand of condom comes from the three words; Durability, Reliability and Excellence.

Truth / Bull
□ □
□ □
□ □
□ □

2 Sharks don't blink their eyes.

Truth / Bull
□ □
□ □
□ □
□ □

3 Pogonology is the study of beards.

Truth / Bull
□ □
□ □
□ □
□ □

4 The name of the dance "Lambada" means "making love while standing".

Truth / Bull
□ □
□ □
□ □
□ □

5 In the year 2000, Bruce Willis was making more money than any other actor in Hollywood.

Truth / Bull
□ □
□ □
□ □
□ □

ANSWER

1 TRUTH

2 TRUTH

3 TRUTH

4 BULL
It's said that the dance got its name from the
Portuguese word for whiplash.

5 TRUTH
Bruce raked in a lazy US$70 million during 2000.

QUESTION

1 Musician Neil Young's real name is actually Neil Oldman.

Truth / Bull
☐ ☐
☐ ☐
☐ ☐
☐ ☐

2 The thinnest skin on a man is around his scrotum.

Truth / Bull
☐ ☐
☐ ☐
☐ ☐
☐ ☐

3 The tyre and rubber company Goodyear invented the first rubber condom.

Truth / Bull
☐ ☐
☐ ☐
☐ ☐
☐ ☐

4 George Harrison was the youngest member of the Beatles.

Truth / Bull
☐ ☐
☐ ☐
☐ ☐
☐ ☐

5 Gonorrhoea has the following three symptoms:
- burning sensations when urinating
- discharge from the urethra, vagina or rectum
- an inflamed throat

Truth / Bull
☐ ☐
☐ ☐
☐ ☐
☐ ☐

ANSWER

1 BULL

2 BULL
The eyelid and the armpit have the thinnest skin.

3 TRUTH
In the late 19th century, Charles Goodyear invented the vulcanization process and made it possible to produce condoms made from rubber.

4 TRUTH
Ringo was the oldest.

5 TRUTH
The symptoms usually show within a week of infection. You can also be infected without having any symptoms at all.

QUESTION

1 Helium is the most common element in the universe.

Truth / Bull
☐ ☐
☐ ☐
☐ ☐
☐ ☐

2 Keanu Reeves' first name means "cool breeze over the mountains" in Hawaiian.

Truth / Bull
☐ ☐
☐ ☐
☐ ☐
☐ ☐

3 James Earl Jones who played Darth Vader in Star Wars, stuttered so badly as a child, that he pretended to be mute in school to avoid speaking.

Truth / Bull
☐ ☐
☐ ☐
☐ ☐
☐ ☐

4 Male singers known as castratos were featured in Vatican choirs until 1961. Castratos where castrated as children so that they could retain their high singing voices.

Truth / Bull
☐ ☐
☐ ☐
☐ ☐
☐ ☐

5 In Kazakhstan it's considered extravagantly beautiful to wear a winter coat made of kitten fur.

Truth / Bull
☐ ☐
☐ ☐
☐ ☐
☐ ☐

ANSWER

1 BULL
Hydrogen is the most common element.

2 TRUTH

3 TRUTH

4 BULL
The practice was stopped 50 years earlier, in 1911.

5 BULL

QUESTION

1 India produces the most feature films in the world.

Truth / Bull
☐ ☐
☐ ☐
☐ ☐
☐ ☐

2 The word "pathetic" comes from the Greek word "pathetikos".

Truth / Bull
☐ ☐
☐ ☐
☐ ☐
☐ ☐

3 At the end of the 14th century, hairdressers were the only people permitted to perform the act of bloodletting.

Truth / Bull
☐ ☐
☐ ☐
☐ ☐
☐ ☐

4 Aluminium is the most common metal in the earth's crust.

Truth / Bull
☐ ☐
☐ ☐
☐ ☐
☐ ☐

5 The world's first skyscraper was built at the end of the 19th century.

Truth / Bull
☐ ☐
☐ ☐
☐ ☐
☐ ☐

ANSWER

1 TRUTH
Almost 1000 movies are produced every year in India

2 TRUTH

3 TRUTH

4 TRUTH

5 TRUTH
The Home Insurance Building in Chicago is counted as the first skyscraper in the world and was 10 stories (42 meters) high. It was built in 1885, but was torn down in 1931.

QUESTION

Oscar Wilde used the pseudonym Sebastian Melmoth.

Truth / Bull
☐ ☐
☐ ☐
☐ ☐
☐ ☐

Twelve men have been on the moon.

Truth / Bull
☐ ☐
☐ ☐
☐ ☐
☐ ☐

Icelandic currency does not contain coins.

Truth / Bull
☐ ☐
☐ ☐
☐ ☐
☐ ☐

After extensive research, an ice cream company discovered that a person uses around 50 licks to eat a regular ice cream.

Truth / Bull
☐ ☐
☐ ☐
☐ ☐
☐ ☐

Brad Pitt has participated in three movies with the number 7 in them.

Truth / Bull
☐ ☐
☐ ☐
☐ ☐
☐ ☐

ANSWER

1 TRUTH

2 TRUTH

3 BULL

4 TRUTH
Ice cream company GB made serious research into the subject.

5 TRUTH
The movies are Seven, Seven years in Tibet and Sinbad: Legend of the Seven Seas.

QUESTION

The sun contains more than 99 percent of our solar system's gathered substance.

Truth / Bull

☐ ☐
☐ ☐
☐ ☐
☐ ☐

Jane Austen died in 1917 at only 42 years of age.

Truth / Bull

☐ ☐
☐ ☐
☐ ☐
☐ ☐

According to legend, the board game Bingo was originally called "beano" as beans were used to cover the numbers on the board.

Truth / Bull

☐ ☐
☐ ☐
☐ ☐
☐ ☐

Singer Ed Harcourt and the pop group Westlife have both had a hit with word "apple" in the title.

Truth / Bull

☐ ☐
☐ ☐
☐ ☐
☐ ☐

The word "paparazzi" comes from a movie in which one of the characters was a celebrity photographer named Paparazzo.

Truth / Bull

☐ ☐
☐ ☐
☐ ☐
☐ ☐

ANSWER

1
TRUTH

2
BULL
Jane Austin died in 1817 at the age of 42.

3
TRUTH
The name used today was adopted when someone shouted "bingo!" after winning.

4
BULL
Ed Harcourt gained success singing Apple of My Eye, but Westlife has never climbed any hit lists with apple related songs.

5
TRUTH
The movie was La Dolce Vita in 1960.

QUESTION

The New Testament was first written in Greek.

Truth / Bull

☐ ☐
☐ ☐
☐ ☐
☐ ☐

Morphine is extracted from the poppy flower.

Truth / Bull

☐ ☐
☐ ☐
☐ ☐
☐ ☐

The very first winter Olympics were held in France.

Truth / Bull

☐ ☐
☐ ☐
☐ ☐
☐ ☐

Alexander the Great was educated by
the great philosopher Aristotle.

Truth / Bull

☐ ☐
☐ ☐
☐ ☐
☐ ☐

The traditional British dish known as Bath Chaps is
made from a cow's teats.

Truth / Bull

☐ ☐
☐ ☐
☐ ☐
☐ ☐

ANSWER

1 TRUTH

2 TRUTH
Just like opium, morphine comes from the opium poppy.

3 TRUTH
They were held in Chamonix, France in 1924.

4 TRUTH

5 BULL
Bath Chaps (originating from the British city of Bath)
is made from a pig's cheeks.

QUESTION

Ozzy Osbourne has five children.

Truth / Bull

□ □
□ □
□ □
□ □

The "3G" in the world of mobile phones stands for "three giants" and refers to the United States, Canada and Japan, which were the three countries that collaborated in the early launch of the phone's revolutionary technology.

Truth / Bull

□ □
□ □
□ □
□ □

Valentina Tereshkova was the first woman to climb Mount Everest.

Truth / Bull

□ □
□ □
□ □
□ □

Catherine Zeta Jones and Michael Douglas share the same birthday.

Truth / Bull

□ □
□ □
□ □
□ □

An adult man has a higher pulse than a young child.

Truth / Bull

□ □
□ □
□ □
□ □

ANSWER

1
TRUTH
As well as the kids he has with Sharon (Kelly, Jack and Aimee), Ozzy has two other children from a previous marriage.

2
BULL
3G stands for "third generation".

3
BULL
She was the first woman in space 1963.

4
TRUTH
Both actors are born on September 25th.

5
BULL

QUESTION

1 August 13th is the international day for left handed people.

Truth / Bull
□ □
□ □
□ □
□ □

2 The fallow deer is the largest in the deer family.

Truth / Bull
□ □
□ □
□ □
□ □

3 Hugh Grant's middle name is Mungo.

Truth / Bull
□ □
□ □
□ □
□ □

4 Julius Ceasar's favourite fruit was strawberries.

Truth / Bull
□ □
□ □
□ □
□ □

5 There are more lakes in Finland than anywhere else on Earth.

Truth / Bull
□ □
□ □
□ □
□ □

ANSWER

1 TRUTH

2 BULL
The moose is the largest in the deer family.

3 TRUTH

4 BULL
The strawberry is a hybrid of three different types of wild strawberries and was not introduced to until the 18th century.

5 BULL
Canada has the largest number of lakes in the world.

QUESTION

1 Y chromosome sperm swims faster than X chromosome sperm.

Truth / Bull
☐ ☐
☐ ☐
☐ ☐
☐ ☐

2 There are no public baths in Uzbekistan.

Truth / Bull
☐ ☐
☐ ☐
☐ ☐
☐ ☐

3 The Hawaiian phrase "ai hea lua" means "where is the bathroom?"

Truth / Bull
☐ ☐
☐ ☐
☐ ☐
☐ ☐

4 At altitudes of 10,000 meters, your taste buds improve by almost 30 percent and you can experience over 100 new flavours impossible to detect on the ground.

Truth / Bull
☐ ☐
☐ ☐
☐ ☐
☐ ☐

5 There are rhinoceros in India.

Truth / Bull
☐ ☐
☐ ☐
☐ ☐
☐ ☐

ANSWER

1 TRUTH
They are also weaker and die sooner.

2 BULL

3 TRUTH

4 BULL

5 TRUTH

QUESTION

1. Each June in Turkey, a celebration is held in honour of the humble cherry.

Truth / Bull
☐ ☐
☐ ☐
☐ ☐
☐ ☐

2. In 1554, a Portuguese noble woman bit off two fingers of the embalmed saint Francis Javier.

Truth / Bull
☐ ☐
☐ ☐
☐ ☐
☐ ☐

3. There are 58 keys on a standard piano.

Truth / Bull
☐ ☐
☐ ☐
☐ ☐
☐ ☐

4. According to the Guinness Book of Records, American Johnny Rabb is the fastest drummer in the world. He can hit more than 1000 drumbeats per minute.

Truth / Bull
☐ ☐
☐ ☐
☐ ☐
☐ ☐

5. The kayak was invented by the Eskimos.

Truth / Bull
☐ ☐
☐ ☐
☐ ☐
☐ ☐

ANSWER

1 TRUTH

2 BULL
She bit off his toe.

3 BULL
They are 88.

4 TRUTH
His actual record is 1071 beats per minute.

5 TRUTH

QUESTION

The Bible states that the owner of an uncovered well is responsible to compensate the owner of any bull or ass that falls into it and return the dead animal to the owner.

Truth / Bull
□ □
□ □
□ □
□ □

In the old days, menstrual blood was used in magic rites in order to rouse a man's love.

Truth / Bull
□ □
□ □
□ □
□ □

A 9000-year-old woman's skeleton that was found in Bulgaria a few years ago was given the name Julia Roberts, owing to the skeleton's perfect set of teeth.

Truth / Bull
□ □
□ □
□ □
□ □

An autopsy of Elvis Presley's body discovered 20 different types of drugs in the King of Rock n Roll's blood.

Truth / Bull
□ □
□ □
□ □
□ □

The largest strawberry in the world was found in Lyon, France, in 1985. It weighed as much as 414 grams, almost half a kilo.

Truth / Bull
□ □
□ □
□ □
□ □

ANSWER

1 TRUTH
In the second Pentateuch contains a plethora of bull-related regulations.

2 TRUTH

3 TRUTH

4 BULL
Elvis had 14 different types of drugs in his body at the time of his death.

5 BULL
The largest strawberry was found in Kent, England and it weighed 231 grams.

QUESTION

Truth / Bull

1 Up to 18 % of the American population believe that the word "erotic" has something to do with space.

☐ ☐
☐ ☐
☐ ☐
☐ ☐

Truth / Bull

2 The population of Britain consumes 165 million cups of tea a day which equates to 3 cups per Brit per day.

☐ ☐
☐ ☐
☐ ☐
☐ ☐

Truth / Bull

3 Leonardo DiCaprio once said that he finds kissing disgusting and that a dog's mouth is cleaner than a human's.

☐ ☐
☐ ☐
☐ ☐
☐ ☐

Truth / Bull

4 Jack Nicholson is the proud owner of a considerable collection of Swedish and Danish porn films from the 1960's and 70's.

☐ ☐
☐ ☐
☐ ☐
☐ ☐

Truth / Bull

5 Belgian scientists have discovered a virus among chimpanzees in Cameroon closely related to the HIV-virus. This chimpanzee-virus is called SIV.

☐ ☐
☐ ☐
☐ ☐
☐ ☐

ANSWER

1 BULL

2 TRUTH

3 TRUTH

4 BULL

5 TRUTH

QUESTION

In the British magazine Guardian Weekly, princess Madeleine of Sweden was once described "as Kylie Minogue, only taller and trickier to get into bed".

☐ ☐
☐ ☐
☐ ☐
☐ ☐

Truth / Bull

Lego was originally used as an orthopaedic aid for those with rheumatic diseases.

☐ ☐
☐ ☐
☐ ☐
☐ ☐

Truth / Bull

Some goats are able to urinate on their own heads, creating an alluring scent to attract females.

☐ ☐
☐ ☐
☐ ☐
☐ ☐

Truth / Bull

Sylvester Stallone was fifteen years old when his classmates voted him most likely to end up in the electric chair.

☐ ☐
☐ ☐
☐ ☐
☐ ☐

Truth / Bull

The expression "hat trick" originally comes from the sport of lawn bowls in which the bowler to hit three strikes in a row was given a big, black hat to carry their balls in.

☐ ☐
☐ ☐
☐ ☐
☐ ☐

ANSWER

1 BULL

2 BULL
Lego has always been a toy. The name comes from the Danish words "lek godt" which means "play good".

3 TRUTH

4 TRUTH

5 BULL
The term "hat trick" was first used in cricket. A player who made three wickets in a row was given a hat.

QUESTION

Tiger Woods first name is actually Tahoma.

Truth / Bull

☐ ☐
☐ ☐
☐ ☐
☐ ☐

The Langerhans Islands are situated in
the Caribbean.

Truth / Bull

☐ ☐
☐ ☐
☐ ☐
☐ ☐

In northern Siberia there is an isolated tribe of peo-
ple who, because of the bitter cold, communicate
up to 50% of the time with body language. This en-
ergetic language utilises the entire body including
knee and hip movements.

Truth / Bull

☐ ☐
☐ ☐
☐ ☐
☐ ☐

Starlings don't have their own bird call, but rather
copy the calls of other birds.

Truth / Bull

☐ ☐
☐ ☐
☐ ☐
☐ ☐

Ringo Starr once appeared in a Japanese commer-
cial for apple sauce – a fitting role for the Beatle as
"ringo" means apple sauce in Japanese.

Truth / Bull

☐ ☐
☐ ☐
☐ ☐
☐ ☐

ANSWER

1 BULL
Tiger's real name is Eldrick. The nickname Tiger was given to him by a friend of his father.

2 BULL
These "islands" are actually cells in your pancreas.

3 BULL

4 TRUTH

5 TRUTH

QUESTION

The movie Pretty Woman was originally titled 3000 after the sum of money Richard Gere's character pays for one week's company with an escort.

Truth / Bull

A German study shows that couples who sleep naked together have shorter periods of intercourse than couples who wear pyjamas in bed.

Truth / Bull

A survey taken by the Norwegian military service in 1990 showed that 10 percent of respondents believed it would've been better if Germany had won World War II.

Truth / Bull

Antalobi is a disease striking both the auditory nerve and the equilibrium nerve, and is characterized by epileptic type attacks.

Truth / Bull

It is more common in Poland than anywhere in Europe for people to sleep with three pillows each.

Truth / Bull

ANSWER

1 TRUTH

2 BULL

3 BULL

4 BULL

5 BULL

QUESTION

Truth / Bull

1 Mahatma Ghandi didn't eat any meat throughout his lifetime.

☐ ☐
☐ ☐
☐ ☐
☐ ☐

Truth / Bull

2 Nicole Kidman is afraid of butterflies.

☐ ☐
☐ ☐
☐ ☐
☐ ☐

Truth / Bull

3 Every third person in San Francisco is homosexual.

☐ ☐
☐ ☐
☐ ☐
☐ ☐

Truth / Bull

4 Rapper LL Cool J's name stands for "Luxurious Lucky Cool Jehovah".

☐ ☐
☐ ☐
☐ ☐
☐ ☐

Truth / Bull

5 There are more nuns in the world over the age of 90 than there are under 40.

☐ ☐
☐ ☐
☐ ☐
☐ ☐

ANSWER

1 BULL
He ate meat on a few occasions in his youth.

2 TRUTH
Nicole thinks there is something ghostlike and creepy about butterflies.

3 TRUTH

4 BULL
LL Cool J stands for "Ladies Love Cool James"

5 TRUTH

QUESTION

1 The word "disco" means "I dance" in Latin.

Truth / Bull

☐ ☐
☐ ☐
☐ ☐
☐ ☐

2 Charlie Chaplin competed in a Charlie Chaplin look-alike competition in the 1920s and only came third.

Truth / Bull

☐ ☐
☐ ☐
☐ ☐
☐ ☐

3 According to the Bible, God once punished Abraham by ordering him to eat 70 mice.

Truth / Bull

☐ ☐
☐ ☐
☐ ☐
☐ ☐

4 French Prime Minister George Clemenceau wished to be buried standing in his grave facing Mecca.

Truth / Bull

☐ ☐
☐ ☐
☐ ☐
☐ ☐

5 Albert Einstein was asked to be the president of Israel in the 1950s.

Truth / Bull

☐ ☐
☐ ☐
☐ ☐
☐ ☐

ANSWER

1 BULL
Disco is an abbreviation of the French word "discothèque" which springs from the Latin word "discus" meaning "disc".

2 TRUTH

3 BULL

4 BULL
He wished to be buried standing, turned towards Germany.

5 TRUTH

QUESTION

An average American eats 28 pigs during their life time.

Truth / Bull
☐ ☐
☐ ☐
☐ ☐
☐ ☐

Green eyed people are more frequently left handed than people with other eye colours.

Truth / Bull
☐ ☐
☐ ☐
☐ ☐
☐ ☐

In India, the crescent moon is "lying down" and can almost resemble a smile.

Truth / Bull
☐ ☐
☐ ☐
☐ ☐
☐ ☐

An octopus has three hearts.

Truth / Bull
☐ ☐
☐ ☐
☐ ☐
☐ ☐

Sticking your tongue out to other people in old Tibet meant that you were inferior to them.

Truth / Bull
☐ ☐
☐ ☐
☐ ☐
☐ ☐

ANSWER

1 TRUTH

2 BULL

3 TRUTH

4 TRUTH

5 TRUTH
This kind of salutation was only used by the society's lower classes.

QUESTION

1. The putrid smell of vomit is generated by a certain acid also found in parmesan cheese.

Truth / Bull
☐ ☐
☐ ☐
☐ ☐
☐ ☐

2. The computer game The Sims has sold over 100 million copies worldwide.

Truth / Bull
☐ ☐
☐ ☐
☐ ☐
☐ ☐

3. The sport related tradition of the "playoff beard" started when football legend Diego Maradona grew a beard for the football world cup in Mexico 1986 where Argentina took gold.

Truth / Bull
☐ ☐
☐ ☐
☐ ☐
☐ ☐

4. Before ABBA was formed, the four band members had already had successful music careers.

Truth / Bull
☐ ☐
☐ ☐
☐ ☐
☐ ☐

5. In the Disney movie The Lion King, King Mufasa's advisor Zazu is a hippopotamus.

Truth / Bull
☐ ☐
☐ ☐
☐ ☐
☐ ☐

ANSWER

1 TRUTH
The acid is called butyric acid and is one of the ingredients in the popular Italian cheese.

2 TRUTH
The game has been translated into 22 different languages and is sold in 60 countries.

3 BULL

4 TRUTH
Benny and Björn each played in a band and Agneta and Annifrid were solo artists.

5 BULL
Zazu is a loyal hornbill.

QUESTION

The average person loses around 8 kg of skin each year.

Truth / Bull

Bruce Bailey from Iowa blew up 31 balloons using his own farts.

Truth / Bull

The Belgian concept-artist Wim Delvoye is the man behind the installation "Cloaca". Cloaca is a machine resembling a washing machine that makes poo.

Truth / Bull

Two German scientists claim that the three golden teeth belonging to collector Lord Dietmar von Reeken in Dresden once belonged to Napoleon. Von Reeken has refused to let the teeth be examined, saying "There are no goddamn French frog teeth in my collection".

Truth / Bull

A male wildebeest (or gnu) can weigh up to 250 kg.

Truth / Bull

ANSWER

1
BULL
A person loses around 18 kg of skin in a lifetime.

2
BULL
A 13-year-old Washington boy named Andrew Dahl blew up 213 balloons using his nose.

3
TRUTH
The machine is fed with ordinary food which mixes with various acids to create poo.

4
BULL

5
TRUTH

QUESTION

Rodents do not have canine (corner) teeth.

Truth / Bull

☐ ☐
☐ ☐
☐ ☐
☐ ☐

The Vatican is counted as the world's smallest independent country.

Truth / Bull

☐ ☐
☐ ☐
☐ ☐
☐ ☐

During the middle ages, ginger bread was considered to have many medical benefits including contraceptive effects.

Truth / Bull

☐ ☐
☐ ☐
☐ ☐
☐ ☐

Napoleon's baldness inspired a new trend in haircuts among French men toward the end of the 18th century. Fashionable men sported long hair at the neck with short on top and along the sides (now known as a mullet).

Truth / Bull

☐ ☐
☐ ☐
☐ ☐
☐ ☐

Zorro's name comes from the Spanish word for sword.

Truth / Bull

☐ ☐
☐ ☐
☐ ☐
☐ ☐

ANSWER

1 TRUTH

2 TRUTH
The Vatican is only 0.44 square km in size.

3 TRUTH
The cookie was also believed to cure diarrhoea,
psychological diseases and tooth ache.

4 BULL
Napoleon wore a quite traditional short pageboy's cut.

5 BULL
Zorro is Spanish for fox.

QUESTION

Truth / Bull

1 French king Louis XIV was decapitated in 1793. Shortly after his death, it came to light that no portrait was ever made of the king during his reign. The body was immediately exhumed and an artist called. Louis XIV's body was strapped to a chair and his head fixed back into place long enough for a portrait to be made.

☐ ☐
☐ ☐
☐ ☐
☐ ☐

Truth / Bull

2 Native Americans were the first to use tobacco.

☐ ☐
☐ ☐
☐ ☐
☐ ☐

Truth / Bull

3 In the 19th century, German man Leo Geyr von Schweppenburg invented a soft drink that he simply named after himself: "Geyr von Schweppenburg". After his death, the drink was renamed to the more easily pronounced "Schweppes".

☐ ☐
☐ ☐
☐ ☐
☐ ☐

Truth / Bull

4 The dinosaur Atlascopcosaurus is named after the Swedish company Atlas Copco.

☐ ☐
☐ ☐
☐ ☐
☐ ☐

Truth / Bull

5 A small electric device called a "mosquito" has been designed to combat young people looking to cause trouble. The device emits a high frequency sound that can only be heard by young people. The mosquitos has gained popularity in both France and Britain where it is used to chase away street gangs.

☐ ☐
☐ ☐
☐ ☐
☐ ☐

ANSWER

1 BULL

2 TRUTH
The tobacco plant existed only in North America before Columbus arrived.

3 BULL
Leo Geyr von Schweppenburg was actually a general in World War II. The drink Schweppes was made by Jacob Schweppes in the 1780s.

4 TRUTH
Atlas Copco helped finance the excavations that lead to the discovery of this giant lizard.

5 TRUTH

QUESTION

A Japanese inventor has created a type of whistling carrot. This genetically modified vegetable is grown with tiny holes throughout, creating a whistling sound when it is perfectly cooked through.

Truth / Bull

☐ ☐
☐ ☐
☐ ☐
☐ ☐

The Panama hat is not actually from Panama.

Truth / Bull

☐ ☐
☐ ☐
☐ ☐
☐ ☐

In 1939, US president Theodore Roosevelt decided to move the date of Thanksgiving to one week later, in order to create an upswing in Christmas spending, thereby improve the country's economy.

Truth / Bull

☐ ☐
☐ ☐
☐ ☐
☐ ☐

When dogs are happy they wag their tail more to the right, when they feel threatened they wag it more to the left.

Truth / Bull

☐ ☐
☐ ☐
☐ ☐
☐ ☐

Balinese people don't mourn their dead. Instead they talk about the death of their relatives with a smile. If a woman loses her husband, people make jokes about how many other men that are left for her.

Truth / Bull

☐ ☐
☐ ☐
☐ ☐
☐ ☐

ANSWER

1 BULL

2 TRUTH
The Panama hat is actually from Ecuador.

3 TRUTH
The result of this decision was complete confusion. Twenty-three states celebrated Thanksgiving on the new date and twenty-three on the same date as always. Texas and Colorado celebrated on both. The following year Roosevelt changed the holiday back to normal, and also established a rule that no changes were allowed in the future.

4 TRUTH
The difference can be a bit difficult to detect though, as the wagging on both occasions is quite fast.

5 TRUTH
Anthropologists explain this behaviour by the fact that grief is connected to illness in Bali, and is chased away by happiness and smiles.

QUESTION

1 Hercule Poirot, one of Agatha Christie's famous characters, has his roots in Belgium.

Truth / Bull

☐ ☐
☐ ☐
☐ ☐
☐ ☐

2 Brad Pitt's little brother Doug runs a Hollywood gossip website.

Truth / Bull

☐ ☐
☐ ☐
☐ ☐
☐ ☐

3 An American study shows that a female stripper gets more tips when she's ovulating than when she's not.

Truth / Bull

☐ ☐
☐ ☐
☐ ☐
☐ ☐

4 When German troupes invaded Paris in September 1914, the French were forced to send 6,000 soldiers to protect the city. Regular taxis were used to transport the troupes.

Truth / Bull

☐ ☐
☐ ☐
☐ ☐
☐ ☐

5 Boolean algebra is a type of algebra designed for use by primary-school-aged children. Boolean algebra has been trialled in schools throughout the UK and Australia with excellent results.

Truth / Bull

☐ ☐
☐ ☐
☐ ☐
☐ ☐

ANSWER

1 TRUTH

2 BULL
Brad's brother Doug runs an IT-company.

3 TRUTH
This phenomenon is said to be due to the pheromones a woman produces during ovulation.

4 TRUTH
Up to 600 taxis helped save Paris from invasion.

5 BULL
Boolean algebra is certainly not for children. It is a logical calculus of truth values, developed by George Boole in the late 1830s.

QUESTION

1. The Japanese macaque swims in hot springs during winter to keep its body warm.

Truth / Bull
☐ ☐
☐ ☐
☐ ☐
☐ ☐

2. Pylon is a fabric made from a mix of nylon and viscose.

Truth / Bull
☐ ☐
☐ ☐
☐ ☐
☐ ☐

3. A person is born with more bones in their body than they'll have when they die.

Truth / Bull
☐ ☐
☐ ☐
☐ ☐
☐ ☐

4. "Farmer's lung" is a lung disease that mostly affects farmers.

Truth / Bull
☐ ☐
☐ ☐
☐ ☐
☐ ☐

5. Lima, the capital of Peru, was originally called Miami when it was founded in the 16th century.

Truth / Bull
☐ ☐
☐ ☐
☐ ☐
☐ ☐

ANSWER

1 TRUTH
The Japanese macaque is the only monkey that lives in cold and snowy areas.

2 BULL
Pylon is a tower made of wood, metal or concrete, constructed to support bridges or high-tension wires.

3 TRUTH
A baby has approximately 300 bones.
An adult has approximately 206 bones.

4 TRUTH

5 BULL

QUESTION

1. Danish golfer Mianne Bagger caused controversy when she moved to Australia to start playing professionally. Some of her competitors believed that the fact she was born a man gave her an unfair advantage in the women's competitions.

Truth / Bull
☐ ☐
☐ ☐
☐ ☐
☐ ☐

2. Anasteemaphilia is the sexual attraction to a person because of a difference in height.

Truth / Bull
☐ ☐
☐ ☐
☐ ☐
☐ ☐

3. A rebab is a slightly thinner and somewhat sweeter version of rhubarb.

Truth / Bull
☐ ☐
☐ ☐
☐ ☐
☐ ☐

4. If you see a triangle on the washing instructions on your clothes, it means the garment must be dry cleaned.

Truth / Bull
☐ ☐
☐ ☐
☐ ☐
☐ ☐

5. During World War I, Polish troupes recruited a brown bear named Voytek to their force.

Truth / Bull
☐ ☐
☐ ☐
☐ ☐
☐ ☐

ANSWER

1 TRUTH

2 TRUTH

3 BULL
A rebab is a string instrument said to be the forerunner to the violin.

4 BULL
It means the garment can be bleached. The symbol for dry cleaning is a circle.

5 TRUTH
Voytek the bear carried ammunition for the soldiers. It's also said that Voytek drank beer and smoked cigarettes.

QUESTION

1. The expression "a three dog night" comes from the Eskimos and refers to an extremely cold night in which one requires three dogs in the bed to keep warm.

Truth / Bull
☐ ☐
☐ ☐
☐ ☐
☐ ☐

2. The expression "to throw in the towel" does not come from the boxing rink. It originated during swimming competitions when spectators would through towels into the pool in support of the winner.

Truth / Bull
☐ ☐
☐ ☐
☐ ☐
☐ ☐

3. The flag of Greece is the oldest known flag to survive without any changes to its design.

Truth / Bull
☐ ☐
☐ ☐
☐ ☐
☐ ☐

4. In Fiji the deceased are buried face down so that all sins and bad thoughts can seep out of the body before continuing the trip to heaven.

Truth / Bull
☐ ☐
☐ ☐
☐ ☐
☐ ☐

5. Mongolian men have the biggest penises in the world.

Truth / Bull
☐ ☐
☐ ☐
☐ ☐
☐ ☐

ANSWER

1 TRUTH

2 BULL

3 BULL
The Danish flag that is oldest flag in the world.

4 BULL

5 BULL

QUESTION

Truth / Bull

1
Russian Empress Katarina the Great was bitten to death by a kinky, sadistic lover.

☐ ☐
☐ ☐
☐ ☐
☐ ☐

Truth / Bull

2
On Easter Sunday in Armenia, all mirrors are turned around to remind people that Easter is a time of inward reflection.

☐ ☐
☐ ☐
☐ ☐
☐ ☐

Truth / Bull

3
The evil witch in Donald Duck named "Magica de Spell" is called "Hexia de Trick" in the Danish version.

☐ ☐
☐ ☐
☐ ☐
☐ ☐

Truth / Bull

4
The words "God save the Queen" appear along the edge of the British two-pound coin.

☐ ☐
☐ ☐
☐ ☐
☐ ☐

Truth / Bull

5
In Astrid Lindgren's classic children's stories, Pippi Longstocking is happy to be living by herself in Villa Villekulla because no one can make her eat potato dumplings.

☐ ☐
☐ ☐
☐ ☐
☐ ☐

ANSWER

1 BULL
Katarina the Great died from a stroke.

2 BULL

3 TRUTH

4 BULL
The phrase "Standing on the shoulders of giants" actually appears on the coin.

5 BULL
Pippi was actually relieved because she didn't have to take cod liver oil in Villa Villekulla.

QUESTION

Throwing candy wrappers on a Swedish sidewalk is a criminal offence for which one can be imprisoned.

Truth / Bull

☐ ☐
☐ ☐
☐ ☐
☐ ☐

The 1998 film Lock Stock and Two Smoking Barrels is based on a scene from Marcel Proust's In search of lost time.

Truth / Bull

☐ ☐
☐ ☐
☐ ☐
☐ ☐

The 1999 Mazda model LaPuta was quite offensive to the Spanish where la puta means whore.

Truth / Bull

☐ ☐
☐ ☐
☐ ☐
☐ ☐

A Bolero is a ballet, a dance, a piece of clothing, a film from 1934, a cocktail and an apple.

Truth / Bull

☐ ☐
☐ ☐
☐ ☐
☐ ☐

A government so corrupt it can't even maintain a façade of honesty is usually called a kleptocracy.

Truth / Bull

☐ ☐
☐ ☐
☐ ☐
☐ ☐

ANSWER

1 TRUTH

2 BULL
The film's director, Guy Ritchie wrote
the manuscript himself.

3 TRUTH

4 TRUTH

5 TRUTH
The person who holds power in such a state is often
called a kleptocrat.

QUESTION

1

In the beginning of the 20th century, two Englishmen by the names Cockroft and Walton invented the first mobile phone. The phone was cordless and could be moved around on a cart.

Truth / Bull

□ □
□ □
□ □
□ □

2

After the Chernobyl catastrophe of 1986, the Russian army moved in to dispose of the radio active waste. As protection against radiation, the military wore a type of led body suit.

Truth / Bull

□ □
□ □
□ □
□ □

3

Actor couple Paul Bettany and his Oscar winning wife Jennifer Connelly have a son named Stellan.

Truth / Bull

□ □
□ □
□ □
□ □

4

Morphology is the science of plant and animal fossils.

Truth / Bull

□ □
□ □
□ □
□ □

5

Parsley was once used to treat menstrual pain.

Truth / Bull

□ □
□ □
□ □
□ □

ANSWER

1

BULL
Cockroft and Walton achieved the first artificial nuclear reaction in 1932, with the help of a high-voltage accelerator.

2

TRUTH
The original plan was for radio controlled robots clean the area, but the machinery failed due to the radiation.

3

TRUTH
He is named after the Swedish actor Stellan Skarsgård.

4

BULL
Morphology is the science of the internal structure of words as well as a study of the configuration or structure of animals and plants.

5

BULL
Parsley was once believed to prevent intoxication.

QUESTION

Truth / Bull

1 Danish author H.C. Andersen designed the award given at the Oscars.
☐ ☐
☐ ☐
☐ ☐
☐ ☐

Truth / Bull

2 If a tiger and a lion mate,
the result is a liger or tigon.
☐ ☐
☐ ☐
☐ ☐
☐ ☐

Truth / Bull

3 The Frisbee was invented by the Frisbie Pie Company –a pie bakery shop in Connecticut in USA.
☐ ☐
☐ ☐
☐ ☐
☐ ☐

Truth / Bull

4 British woman Sarah Carmen suffers from a disease called Permanent Sexual Arousal Syndrome which can cause her to have more than 200 orgasms in one day.
☐ ☐
☐ ☐
☐ ☐
☐ ☐

Truth / Bull

5 George Crumb worked as a chef in New York in 1853. Frustrated by a patron's complaint that his French fries were too thick, George cut the potatoes paper thin and fried them, creating what we know today as the potato chip.
☐ ☐
☐ ☐
☐ ☐
☐ ☐

ANSWER

1 BULL
American Cedric Gibbons designed the statuette. Gibbons himself was awarded eleven Oscars throughout his career in art direction.

2 TRUTH
A liger has a lion father and a tiger mother. There are a dozen in the world and they can weigh up to 630 kilos. If the animal has a tiger father and a lion mother, it will be a tigon.

3 TRUTH
Employees at Frisbie Pie Company would amuse themselves by throwing pie tins to each other and thus the Frisbee was born.

4 TRUTH

5 TRUTH

QUESTION

1 Al Pacino performed as a stand-up comedian at the beginning of his career.

Truth / Bull
☐ ☐
☐ ☐
☐ ☐
☐ ☐

2 Composer John Cage's work 4'33''
is 4 minutes and 33 seconds of silence.

Truth / Bull
☐ ☐
☐ ☐
☐ ☐
☐ ☐

3 Nail polish used during Cleopatra's time was a mixture of fat, red sand and pig's blood.

Truth / Bull
☐ ☐
☐ ☐
☐ ☐
☐ ☐

4 Andy Warhol's real name was Andy Warhola.

Truth / Bull
☐ ☐
☐ ☐
☐ ☐
☐ ☐

5 The first dog in space, Laika, was nicknamed the "Little Rocket" in American press.

Truth / Bull
☐ ☐
☐ ☐
☐ ☐
☐ ☐

ANSWER

1 TRUTH

2 TRUTH

3 BULL
Nail polish did exist in Cleopatra's time, but it was made of oil, powder and henna.

4 TRUTH

5 BULL
Laika was dubbed "Muttnik".

QUESTION

1

In 1996, animal rights organisation PETA proposed that the city of Fishkill in New York change its name to Fishsave.

Truth / Bull
☐ ☐
☐ ☐
☐ ☐
☐ ☐

2

Swinging was introduced in a German town in the 1960s as a way of promoting love within the small community by switching partners with a neighbour.

Truth / Bull
☐ ☐
☐ ☐
☐ ☐
☐ ☐

3

Italian artist Piero Manzoni is famous for his work "Artist's shit". The work consists of 90 tin cans filled with the artist's own faeces, sold for the same kilo price as gold.

Truth / Bull
☐ ☐
☐ ☐
☐ ☐
☐ ☐

4

To combat the low birth-rate in the Russian city of Ulyanovsk, the council introduced a special "baby making day". After having declared September 12 as the official sex day, child bearing has actually in-creased in the town.

Truth / Bull
☐ ☐
☐ ☐
☐ ☐
☐ ☐

5

Birds that don't make seasonal migration are called "resident birds".

Truth / Bull
☐ ☐
☐ ☐
☐ ☐
☐ ☐

ANSWER

1 TRUTH
The city declined the proposal noting that the word "kill" comes from the Dutch word for stream.

2 BULL

3 TRUTH
The London Tate Gallery bought one of the cans in 2002.

4 TRUTH
If an Ulyanovsk resident has a baby on the national day of June 12 (exactly nine months after the "baby making day"), they can win prizes including a Jeep.

5 TRUTH

QUESTION

Truth / Bull

1
Heidi Krieger competed for the East German track
and field national team in the 1980s. Heidi's coach
doped her with so much male sex hormone that she
decided to have a sex change in the 1990s.

□ □
□ □
□ □
□ □

Truth / Bull

2
If you put a fresh egg in water, it will sink to the bot-
tom. An old egg floats due to the build up of sulfur
inside the egg.

□ □
□ □
□ □
□ □

Truth / Bull

3
Rear-Admiral Robert Edwin Peary is not only known
for being the leader of the first North Pole expedition
that reached its goal, he also proved that Greenland
is an island.

□ □
□ □
□ □
□ □

Truth / Bull

4
Michael Jackson's older brother Jermaine Jackson
has converted to Islam and is now called Moham-
mad Abdoul Aziz.

□ □
□ □
□ □
□ □

Truth / Bull

5
The recipient of a successful bone marrow trans-
plant has two sets of DNA, their own and that of the
donor, for the rest of their life.

□ □
□ □
□ □
□ □

ANSWER

1 TRUTH
Heidi is now known as Andreas.

2 TRUTH

3 TRUTH

4 TRUTH

5 TRUTH

QUESTION

1. Spiders have bluish blood.

Truth / Bull
☐ ☐
☐ ☐
☐ ☐
☐ ☐

2. Poland is a republic.

Truth / Bull
☐ ☐
☐ ☐
☐ ☐
☐ ☐

3. The Komodo dragon can grow up to three meters long, weigh up to 90 kilos and can reproduce without impregnation.

Truth / Bull
☐ ☐
☐ ☐
☐ ☐
☐ ☐

4. Male wrestling is divided into two categories. Greek Roman wrestling forbids holding beneath the hips. Freestyle wrestling permits holds on any part of the body. Female wrestling only has the freestyle category.

Truth / Bull
☐ ☐
☐ ☐
☐ ☐
☐ ☐

5. Women have a lower percentage of blood than men.

Truth / Bull
☐ ☐
☐ ☐
☐ ☐
☐ ☐

ANSWER

1 BULL
Spiders don't have an isolated blood system. Bodily fluids and blood run together and form a yellowish fluid.

2 TRUTH

3 TRUTH

4 TRUTH

5 TRUTH
A man's bodyweight is about 7 percent blood and a woman's is approximately 6 percent blood.

QUESTION

Alexander the Great made beards unfashionable in the 400th century by ordering his soldiers to shave.

Truth / Bull
☐ ☐
☐ ☐
☐ ☐
☐ ☐

Only male Indian elephants have tusks.

Truth / Bull
☐ ☐
☐ ☐
☐ ☐
☐ ☐

Coco Chanel introduced her world renowned perfume Chanel no 5 on the fifth day of the fifth month in 1921.

Truth / Bull
☐ ☐
☐ ☐
☐ ☐
☐ ☐

The film Taxi Driver received the Chinese title Zhong Guha Yu, which translates directly to "car on crazy street".

Truth / Bull
☐ ☐
☐ ☐
☐ ☐
☐ ☐

LSD is a physically addictive drug.

Truth / Bull
☐ ☐
☐ ☐
☐ ☐
☐ ☐

ANSWER

1 TRUTH
Alexander didn't want the enemy to be able to grab his soldiers by their facial hair.

2 TRUTH

3 TRUTH
The number five was Coco Chanel's lucky number.

4 BULL

5 BULL
Unlike other psychedelic drugs, LSD is not physically addictive.

QUESTION

1 A cow can fart about 300 litres of methane gas per day, enough to fill 20 party balloons.

Truth / Bull
☐ ☐
☐ ☐
☐ ☐
☐ ☐

2 The word virus comes from the Latin word for poison.

Truth / Bull
☐ ☐
☐ ☐
☐ ☐
☐ ☐

3 A yak's milk is blue.

Truth / Bull
☐ ☐
☐ ☐
☐ ☐
☐ ☐

4 Walt Disney's first feature film was Pinocchio.

Truth / Bull
☐ ☐
☐ ☐
☐ ☐
☐ ☐

5 According to the Third Pentateuch in the Bible, it is forbidden to eat grasshoppers or cats.

Truth / Bull
☐ ☐
☐ ☐
☐ ☐
☐ ☐

ANSWER

1 BULL
A cow can fart about 600 litres of methane gas per day which would fill up to 40 party balloons.

2 TRUTH

3 BULL

4 BULL
It was Snow White and the Seven Dwarfs.

5 BULL

QUESTION

1 There are two nudist beaches in California that are only open to blind nudists.

Truth / Bull
☐ ☐
☐ ☐
☐ ☐
☐ ☐

2 The world's snail population is 70 percent female.

Truth / Bull
☐ ☐
☐ ☐
☐ ☐
☐ ☐

3 In Japanese, the words "four" and "death" are pronounced the exact same way, as are the words "nine" and "pain". For this reason, many hotels in Japan do not use the numbers 4 or 9 when numbering their hotel rooms.

Truth / Bull
☐ ☐
☐ ☐
☐ ☐
☐ ☐

4 Crayfish blush red when mating.

Truth / Bull
☐ ☐
☐ ☐
☐ ☐
☐ ☐

5 The inventor of the windshield-wiper was initially mocked for her invention. People thought it was better to take the windshield off and simply get wet when it rained.

Truth / Bull
☐ ☐
☐ ☐
☐ ☐
☐ ☐

ANSWER

1 BULL

2 BULL

3 TRUTH

4 BULL

5 TRUTH
Mary Anderson got the patent for her windshield wipers in 1905.